'Uncanny'

Second Printing
Published in 2001 by Houston and Gingko Press

First Printing
Published in 2000, © Houston-Wolfe

Bruce Sterling quote is ©1999 Paper magazine.
Used by permission.

ISBN 1-58423-091-6

Library of Congress Card Number: 00-109669

Printed in Korea

Gingko Press Inc. Houston
5768 Paradise Drive, Suite J 907 East Pike Street
Corte Madera, CA 94925 Seattle, WA 98122
USA USA

Telephone: 415.924.9615 Telephone: 1.800.932.5475
Telefax: 415.924.9608 Telefax: 206.860.7994
books@gingkopress.com houston@wehaveaproblem.com
www.gingkopress.com www.wehaveaproblem.com

ISBN 1-58423-091-6

9 781584 230915

UNCANNY

THE ART & DESIGN OF SHAWN WOLFE

Gingko PRESS

Since 1984
Beatkit
Until 2000

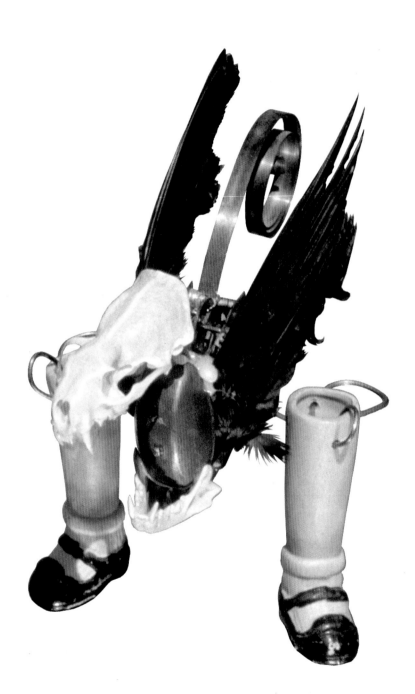

To Jessica and my family

JUN 0 8 2009

Acknowledgements

To my friend and colleague Darick Chamberlin who has been instrumental in Beatkit's evolution as well as my own, and to my friends David Butler and James Towning who were the other two thirds of the original Beat Kit fanzine way back in 1984; *thank you.* I am greatly indebted to David Carson and to Rudy Vanderlans for the influence they have had on me and for bringing my work to a wider audience when no one else seemed willing to do so. And I especially want to thank Matthew Clark. Without his vision, enthusiasm and support this book would never have been possible.

Many sincere thanks also to Eric Fredericksen, Scott Musgrove, Mark Hosler, Ellen Forney, Clarke Fletcher, Michael Minney, Mark Blubaugh, Risa Blythe, Dan Sarka, Pete Lockner, Chas Krider, Richard Lyons, Don Joyce, Mark Frauenfelder, Tony Millionaire, Jim Woodring, Jason Lutes, Art Chantry, Sean Tejaratchi, Erik Brunetti, Jesse Paul Miller, Meg Shiffler, Matthew Richter, Jacob McMurray, Sally Johnson, Derek Mazzone, Reginald Watts, Richard Peterson, Dale Yarger, Mason Nichol, Ian Adelman, Nick Sherman, Amy Lam, Rick Patrick, Amy Guip, Brian Wallace, Stuart Williams, Walter Wright, Wade Weigal, Pamela Krider, Michael Washer, Stefano Gaudiano, De Kwok, Arbito, Bwana Spoons, Spike Vrusho, Nancy Kangas, Greg Bonnell, Donald McKinlay, Dan Paulus, Hank Trotter, Sean Miller, Amy Butler, Andrew Shuman, Jimmy Malecki, Duncan Smith, Christian Palmer, Christian French, Tamara Burke, John Seal, Deanna Brown, Brian Blair, Ellen Hoover, Brian Colwell, Julie Dubrouillet, Steve Brannon, John Walsh, Mike Bianchi, Ken Miracle, Jim Sheely, Rob Harrison, John Roderick, Mike Wells, Aethelred, Neil Gitkind, Dan Bertolet, Kathy Mars, Jason Harler, Ed Grunewald, Susan Hessler, Marion Herbert, Ed Lense, Evelyn Roeder and the whole ARO family: Jared Harler, Alex Calderwood, Caroline Davenport, Margaret Ciezler, Adrian Sosa and Nasir Rasheed.

Thank you **all** for your inspiration and support.

Shawn Wolfe, Seattle, 2000

BEATKIT WORLD SERVICING

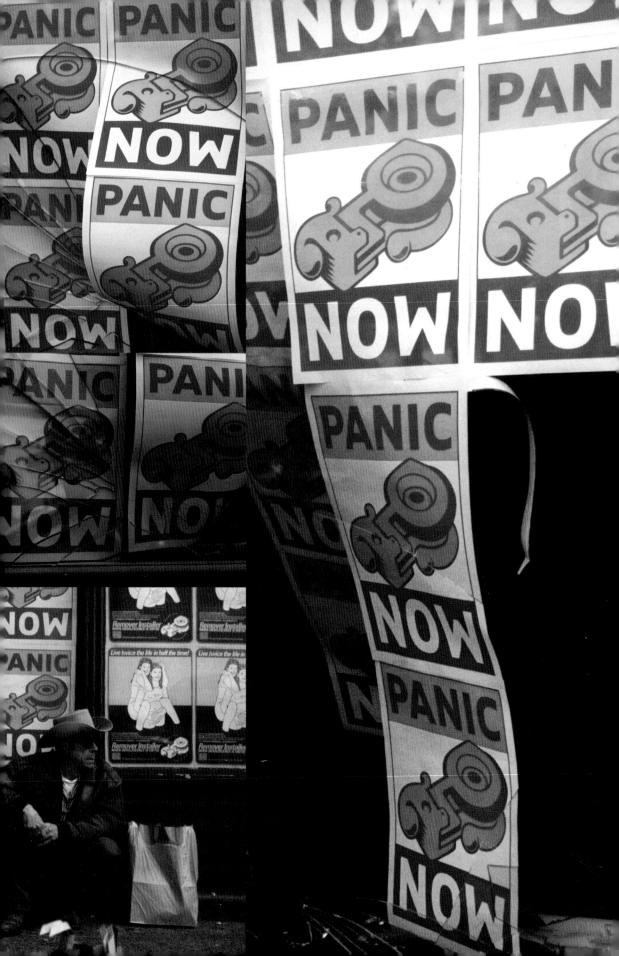

Opposites and rebellion are obsolete.
The fittest shall survive yet the unfit
may live. It's all the same.

— Devo

MICHAEL SHAWN WOLFE

SHAMEFACE WHO'LL WIN

A CLASH WHEN I'M WOLFE

A FLAW SCENE? HIM HOWL

I'M A NEW SHALLOW CHEF

A MACHO SHELL? FEW WIN

Moving The Markers

There are many paths to follow as a graphic designer. You can concentrate on producing annual reports for corporations, specialize in designing signage systems, create intricate maps and graphs at a newspaper, or become an art director at a life-style magazine. You can work in an advertising agency and put your talents to work seducing the masses into buying products they don't need, or you can design poetry books for small independent publishers. You can create CD covers for major or minor record labels, or be part of a team of designers redesigning the identity of a multi-national corporation. You can put together web sites, do film titles, design clothing tags and logos and letterheads and book covers, or design labels to help people better understand the contents of a bottle of cough syrup. Graphic design can be applied in myriad ways, and there are as many different types of graphic designers as there are jobs. But they all have one thing in common: graphic designers need clients. Graphic design happens by commission. It waits for opportunity. It is a reaction. Art, on the other hand is pure action. It needs only the active mind of the artist to spring to life. It creates opportunity. This is what sets art and graphic design apart. For the most part, at least.

Shawn Wolfe is a graphic designer in the traditional sense of the word. Or so it would seem at first glance. He has various clients who give him commissions. But there's another dimension to Wolfe. Tired, perhaps, of waiting for opportunity to come knocking, Wolfe took action. He started a company called "Beatkit" which, parallel to his "professional" practice, generates graphic design, but without the commissions of clients. Beatkit produces and distributes its own posters, ads, magazines, T-shirts, stickers, etc. Beatkit even has a logo, a serious-looking logo.

What Beatkit manufactures looks suspiciously like graphic design. It feels and smells like graphic design. Until you take a closer look. Then you notice that the posters have a lot to say, but ultimately tell us what appears to be nothing, that the ads advertise products that don't exist, and that the Beatkit logo states "From 1984, Until 2000." Imagine that, a company that knows, at its inception, when to call it quits.

What's Wolfe's racket?

Graphic designers are visual spin doctors. They take the raw information handed to them by their clients, give it a twirl, and then present it to the public. They gloss and buff and generally make the information (and by extension the clients) look much better than it really is. As such they help create a reality that is mediated to various degrees. The public accepts it as the truth because it looks professional.

Wolfe's Beatkit products look professional, too. They seduce us. They seem to have real purpose. This is how he draws us in. But then we find out he delivers nothing. At least nothing we expect. Instead, his work exposes the levels of conceit inherent in most printed matter. He reminds us that the world around us is man-made, and that we would do well to question it on occasion. Wolfe's work is like a distorting mirror held up to the face of this manufactured world. He deftly and selectively appropriates the familiar language and imagery of style and commerce with the self-assurance of a weathered graphic designer—his years of working on the "inside" as a design hack paying dividend. And while some may argue that Wolfe in his Beatkit persona is really an artist, not a graphic designer (after all, Beatkit has no clients), it is his ability to draw on graphic styles so cunningly that sets him apart from most artists who in their work deal with the issues of commercialism and mass communication.

Wolfe has seized an opportunity. He has created a hybrid form allowing design to be an action. By sidestepping the traditional ways of operating as a designer, and by using the means of graphic design to comment on itself, new opportunities are created for design. The question is, without a client footing the bill and distributing the goods, is there an opportunity for this work to evolve into something permanent, something that can continue to be explored? Beatkit's promise to end its run in Y2K may indicate that Wolfe himself realizes the limitations of his ways. I predict Beatkit will return in some configuration or another. Once you free yourself from the traditional restraints of graphic design, as Wolfe did, it's difficult to give that up.

Rudy VanderLans, Berkeley, 1999

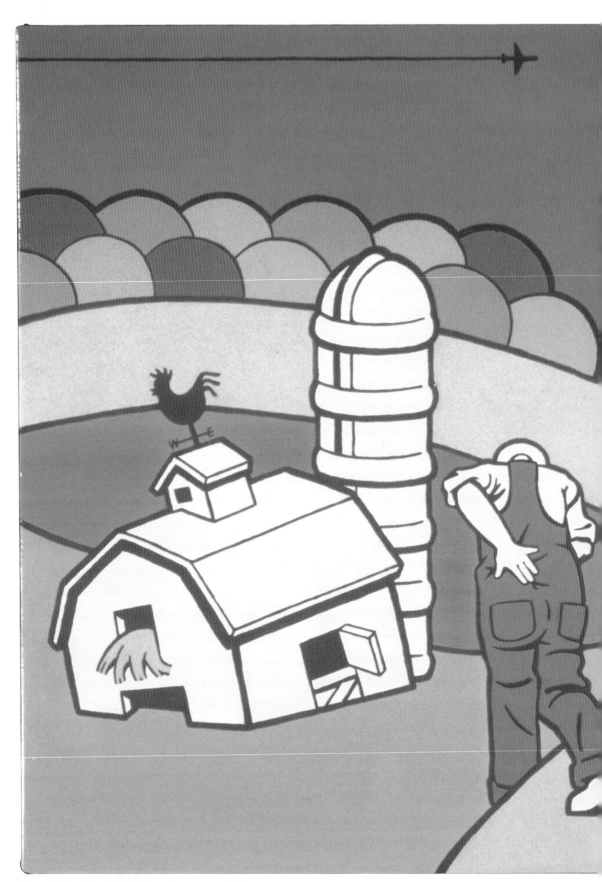

What Are People For?, 26"x38" acrylic on canvas, 1998

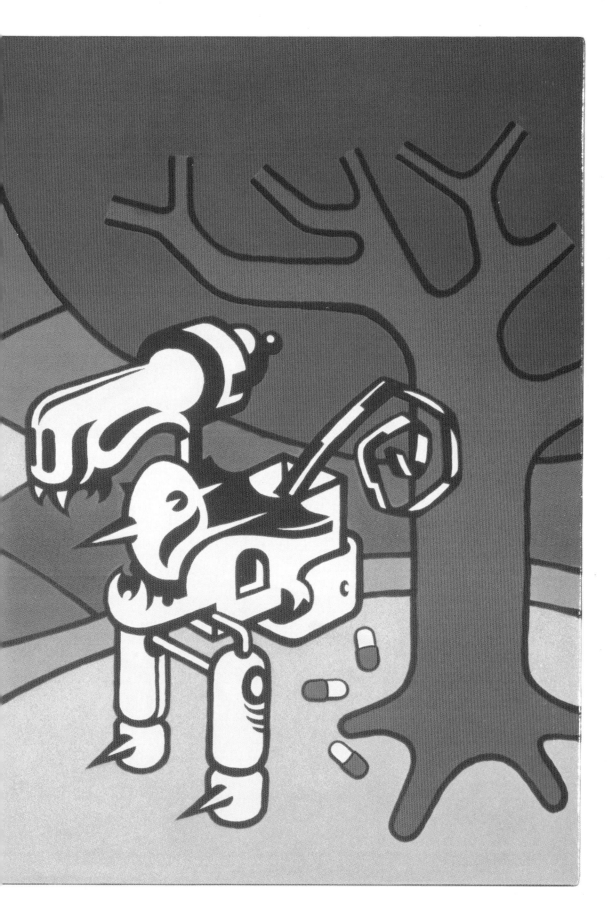

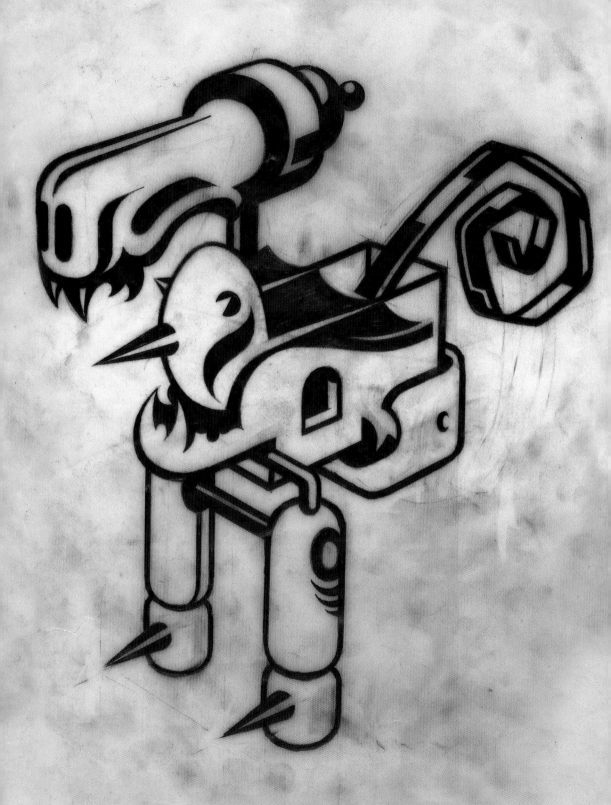

Bionic Cat #3, preliminary drawing, 1990

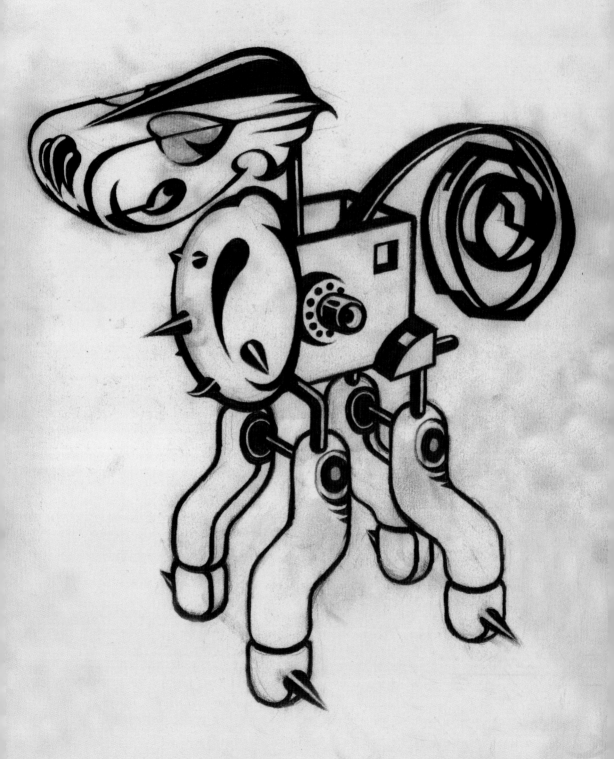

Bionic Cat #1, preliminary drawing, 1990

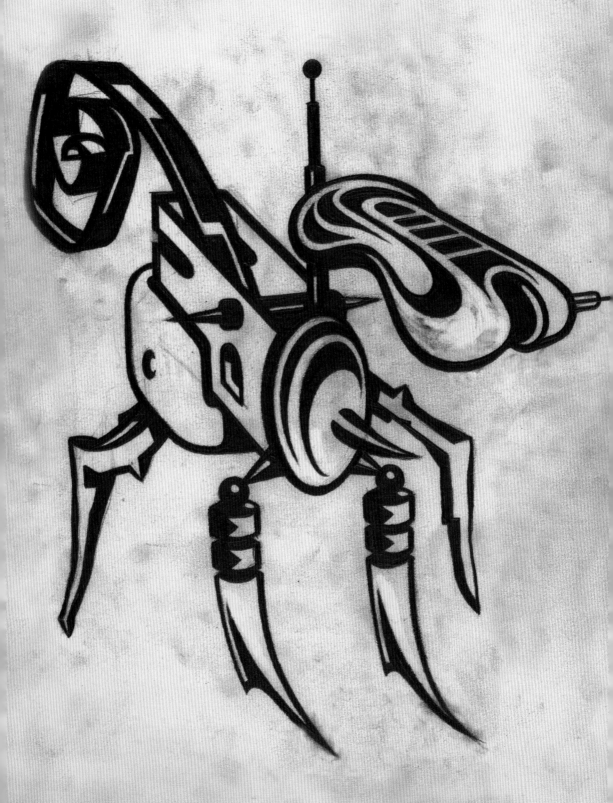

Bionic Cat #2, preliminary drawing, 1990

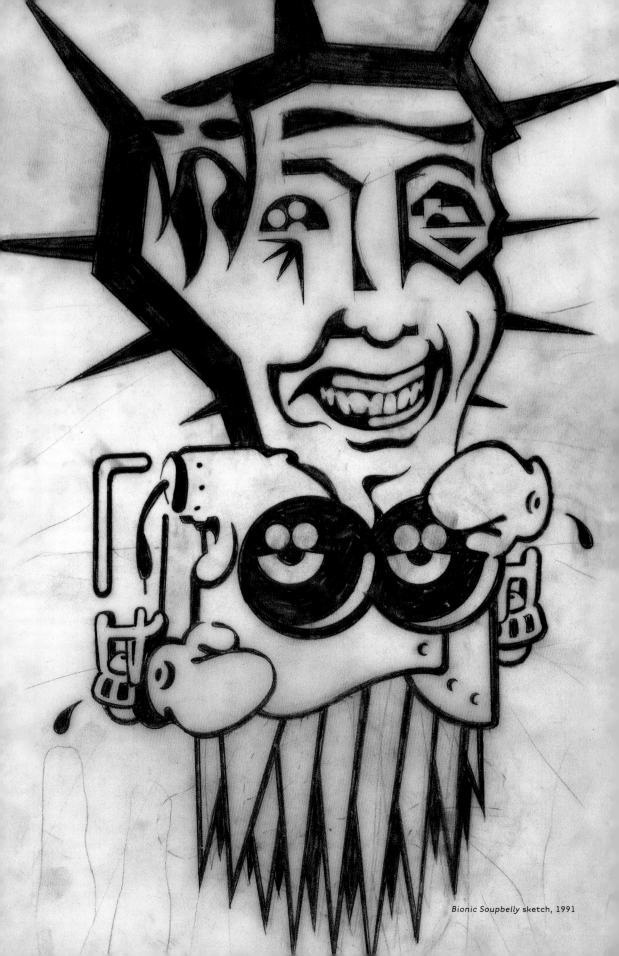

Bionic Soupbelly sketch, 1991

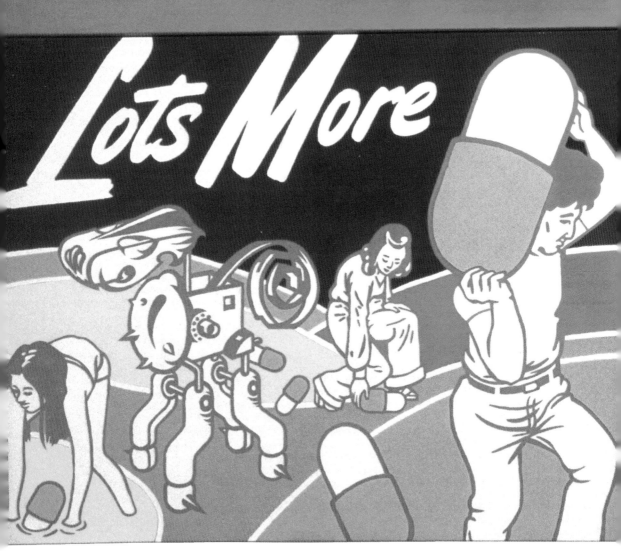

Here It Is! Lots More, 48"x36" acrylic on canvas, 1999

it is!

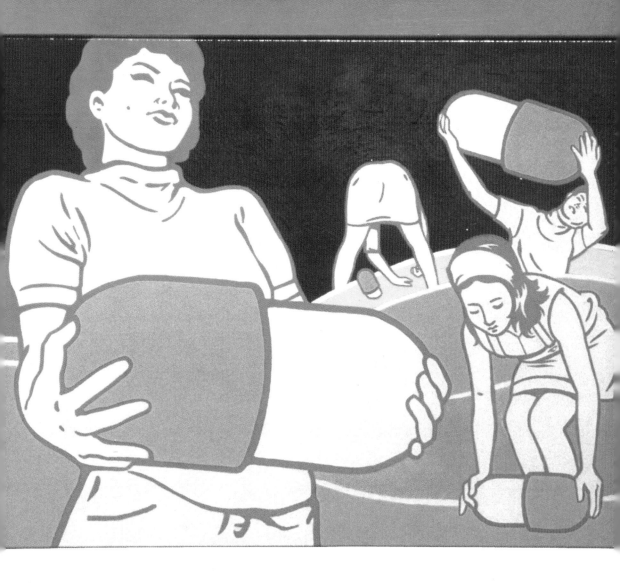

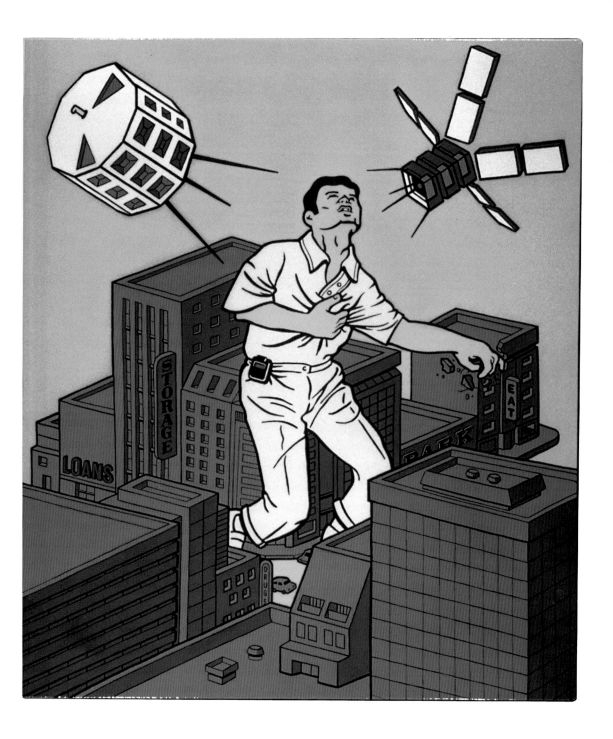

The Pencil and the Swoosh

Shawn Wolfe's consummately artificial, mediated, inauthentic, brand-driven, media-saturated, consumer-culture-satirizing world has surprising origins: a pencil and a piece of paper. Behind the final products he shows the world—the poster, stickers, handbills, magazine layouts, CD covers, and advertisements, both fake and real—are the simple graphite drawings where his cast of synthetic, biomorphic objects are conceived.

this page:
Massive Attack, 48"x60" acrylic on canvas, 1998

opposite:
Hubris Repaid, sketch, 1990

The Visible RemoverInstaller, 36"x20" medical lightbox & duratrans, 1999

The signal mark of Wolfe's work is its extreme non-referentiality. While he is often engaged in a careful critique of the languages of advertising and brand-promotion, his work rarely relies on existing brands or advertisements as its raw material. (There are exceptions, as in his revision of the NASA logo or his commissioned work for Negativland's *Dispepsi* CD.) Wolfe's brands exist in a parallel, self-created universe that can mimic the sense/nonsense of a Nike or Coke campaign, but without mimicking the brands themselves. His ability to generate free-standing icons allows him to satirize the new strain of consumer culture, where specific physical products are secondary to the abstract ideas tied up in a brand. His advertisements advertise almost nothing: a series of products (the Bionic Cat, the RemoverInstaller, the Monkeybot, et al.) which have no clear function.

Just as surprisingly, Wolfe's Beatkit "products" often do have a real-world origin. The Bionic Cats (there are several varieties) are drawings based on a sculpture Wolfe built using the guts of an alarm clock, two doll legs, a mink skull and a pair of bedraggled bird wings. A collage once made by a friend inspired a bionic cat precursor, the homunculus "Soupbelly." A certain armless sock monkey pervades his late '80s work. His most enduring creation, however, and the most perfectly stubbornly non-referential—the RemoverInstaller—had no particular outside inspiration. The mechanically complex, utterly incomprehensible device was created in an inspired bout of freehand drawing, where Wolfe played with representational ideas he'd learned in college drafting classes. The completed device is simultaneously readable—it has distinct pieces and a comprehensible structure—and illegible. Its specific, physical function is never demonstrated, only hinted at and implied.

Wolfe repeats the image in a variety of media, even breaking it down into component parts and showing how they fit together in a digital video, while letting the viewer get no closer to an understanding of what it might do. Breathless ad copy written to accompany images of the

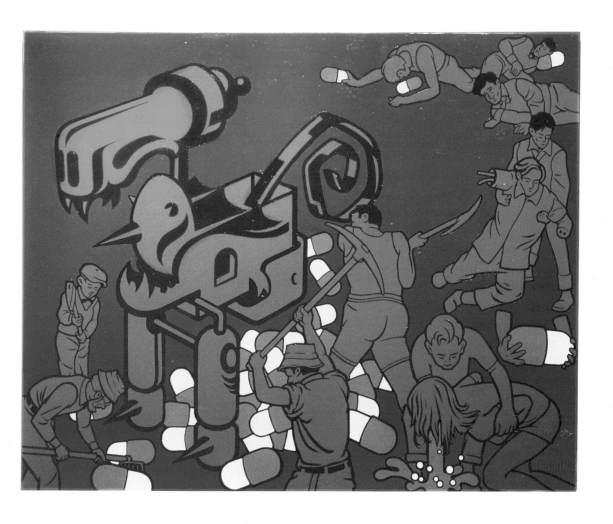

Too Much Of A Good Thing, 90"x72" acrylic on canvas, 1999

device promote its benefits: you can "live twice the life in half the time" by "represent[ing] every detail of your life in full dimension, even when you're away." Some kind of medium which can record your experiences, saving you the bother of having to experience them first-hand, then. It "makes any lifestyle choice easy to dispense," which is helpful in this age when making life-changing, identity-fixing decisions over sneaker brands or soft drinks can be so traumatizing.

Wolfe uses and reuses his stable of images until they achieve the abstract presence of the Nike swoosh, some feat, given the comparative complexity of his images. He tweaks their looks here and there, changing the head of the Bionic Cat or adding a little crank or control arm to the RemoverInstaller, but basically presents them identically each time they appear, allowing them to work as both specific images and as icons. Wolfe's presentation is consistent in form as well as content: the devices are typically presented in a standard orthogonal view in the manner of schematic drawings and architectural renderings.

In the years since 1990 Wolfe has made occasional paintings of his objects and brands. He aims for expressionless paint handling; his early works usually featured a crudely rendered Beatkit trademark alongside one of his supposed "products," as if to underscore the waste of putting such a labor-intensive medium to work simply repeating a brand icon. By hand-painting multiple versions of the same painting, changing only the color scheme and a few small details, Wolfe emphasizes the pointlessness of repeating and perpetuating meaningless brand imagery generally, whether produced by hand or by mechanical means. Pre-mixing small batches of needed colors, Wolfe sets out to approximate the uniformity of printed inks. An eventual switch from oil to acrylic made his work even more perfectly expressionless. Plastic pigments have permitted an opaque, glossy finish and virtually invisible brushwork, allowing him to mimic his computer-assisted work ever more closely.

The RemoverInstaller can do many things, but it's not much of an actor. Which may be why Wolfe

returned to his other great mechanical icon, the Bionic Cat, in more recent paintings. The Bionic Cat, a scary looking creature with spikes on chest and feet and a nasty overbite of sharp fangs, has no discernible cat-like functions. The cat is shown in a variety of renditions, with two legs or four, with a head like a record player tone arm or like a Swingline stapler.

The most successful of the Bionic Cat paintings thus far is *What Are People For?*, done by Wolfe in 1998. The piece shows a bucolic farm scene, with rolling hills, trees, a barn and silo, a farmer in the field—and the Bionic Cat. The painting looks as unnatural as I can imagine a landscape being. Natural forms have a disturbing regularity, as in a double row of trees done as overlapping perfect circles visible over the top of a hill. The rolling hills evoke Coca-Cola's wavy line trademark. The barn is sinking into the earth, the farmer walking away seizing his aching back where he appears to have been bitten by the Bionic Cat, which stands stock still under the tree, three capsules falling from its rear. The cat device is the obvious focal

point of the piece; it seems to have transformed this bucolic scene into a slick, packaged version of "countryside." The cat represents both curse and cure—having just bitten the farmer in his ass, it poops out pills to ease the pain of his injury. Wolfe has continued this theme in subsequent works, showing groups of people harvesting the cat's output of candylike tranquilizers while suffering the occasional seizure or dismember-ment caused by same.

Wolfe's posters and web pages have used text in combination with images to build rich ideas of commodification around his objects. Here he achieves a similar effect with only the odd juxtapositions of imagery. Using the simple technologies of pencil and paint, he creates simple forms for thinking about complex contemporary issues.

Eric Fredericksen, Seattle, 1999

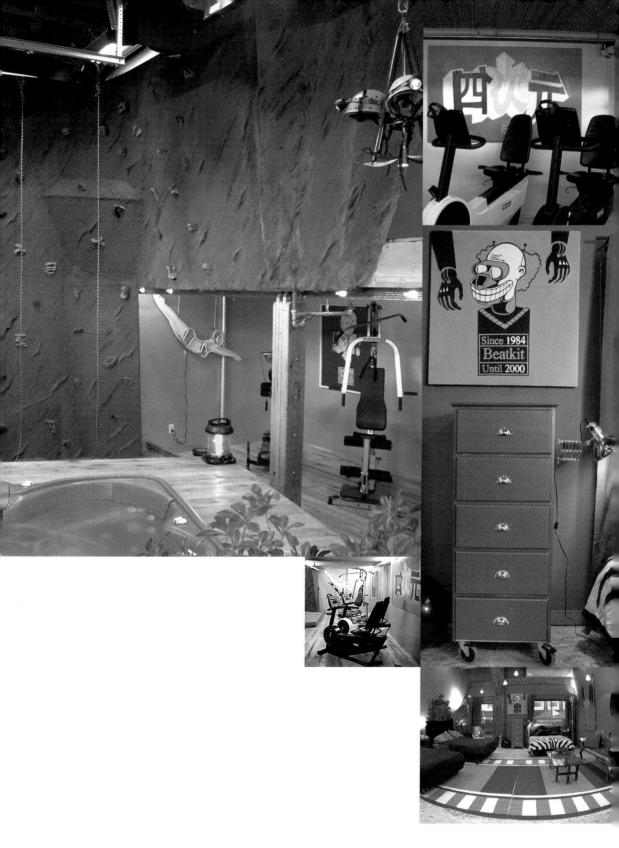

this page:
The Real World, Seattle
Beatkit canvases as situationist stage dressing
photos ©1998, Jimmy Malecki/MTV

opposite:
The 4th Dimension in Japanese with Logo, 48"x66" acrylic on canvas, 1991

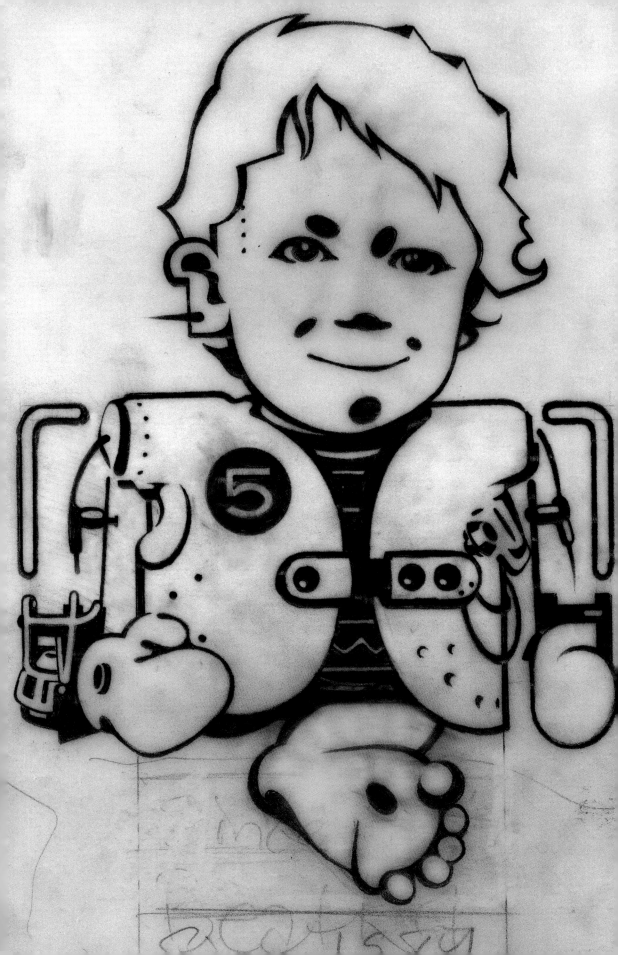

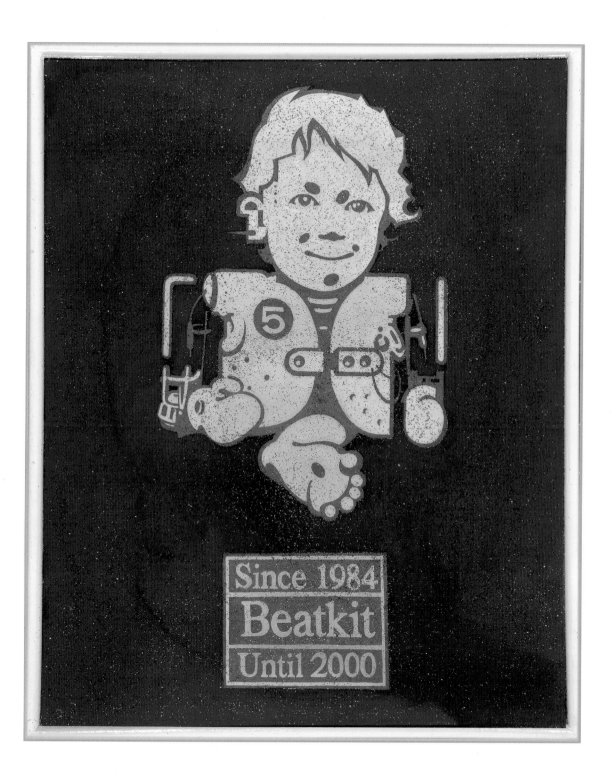

this page:
Custom With Logo, 34"x42" acrylic on canvas, 1990

opposite:
Custom (Thalydamide baby from Life magazine, circa 1960), preliminary sketch, 1990

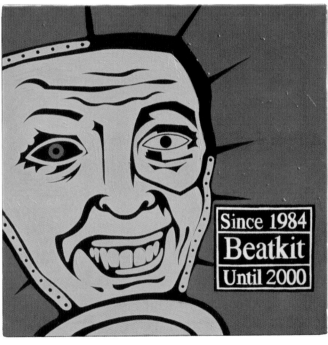

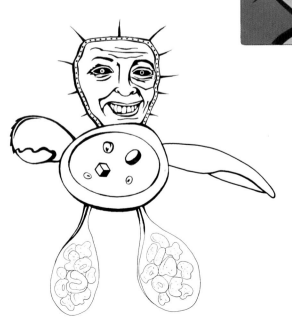

top:
Soupbelly, 6"x7" newsprint collage, 1989
Mark Blubaugh

center:
Soupbelly Head With Logo, 25" x 25" oil on canvas, 1990

bottom:
Soupbelly sketch, 1990

opposite:
Bionic Soupbelly Installer, preliminary drawing, 1991

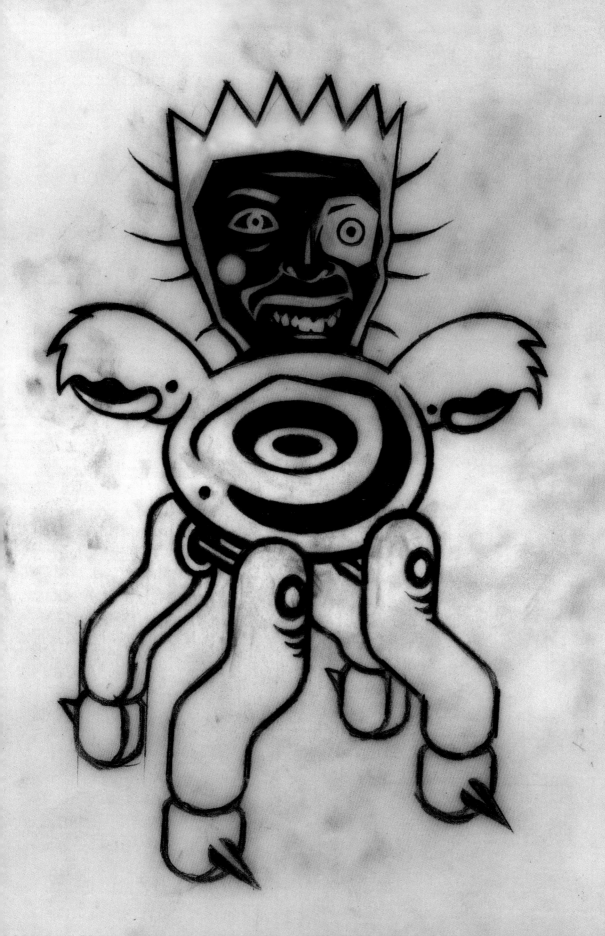

this page:
Looking For The Real Killers with DNALAPDC3POJCNN, acrylic on found reproduction, 54" x 30", 1995

opposite:
The Perfect Couple, 48"x 66" acrylic on canvas, 1993

this page:
Sweet Dream Concussion, 54" x 30" acrylic on canvas, 1999

opposite:
Actual Size With Logo, 32"x 38" acrylic on canvas, 1996

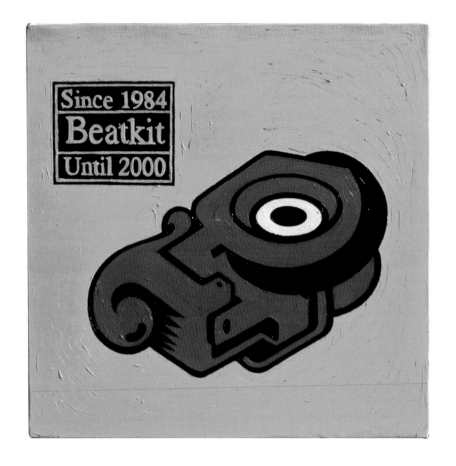

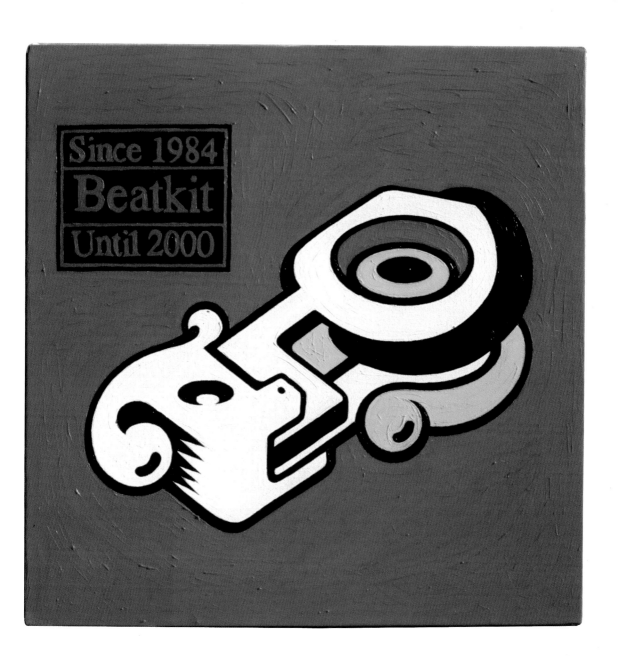

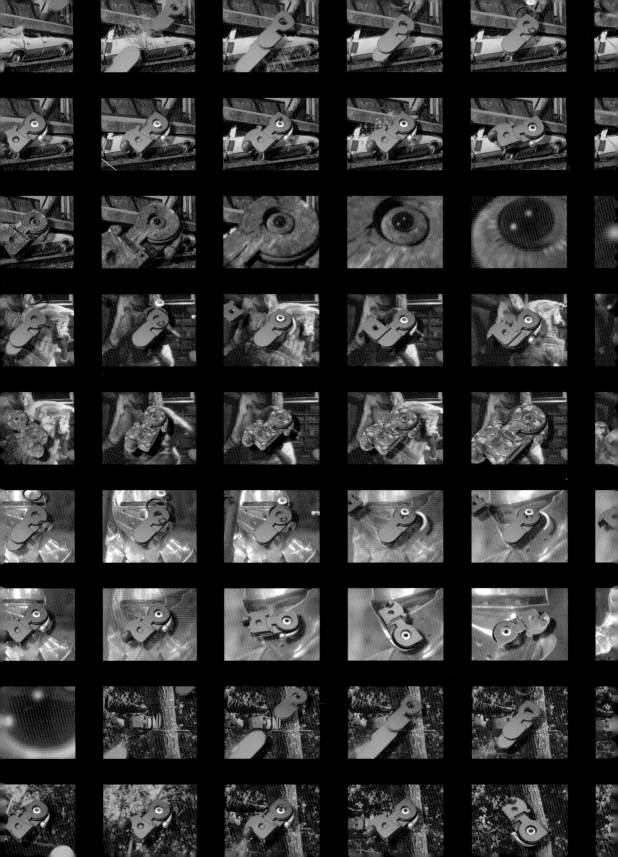

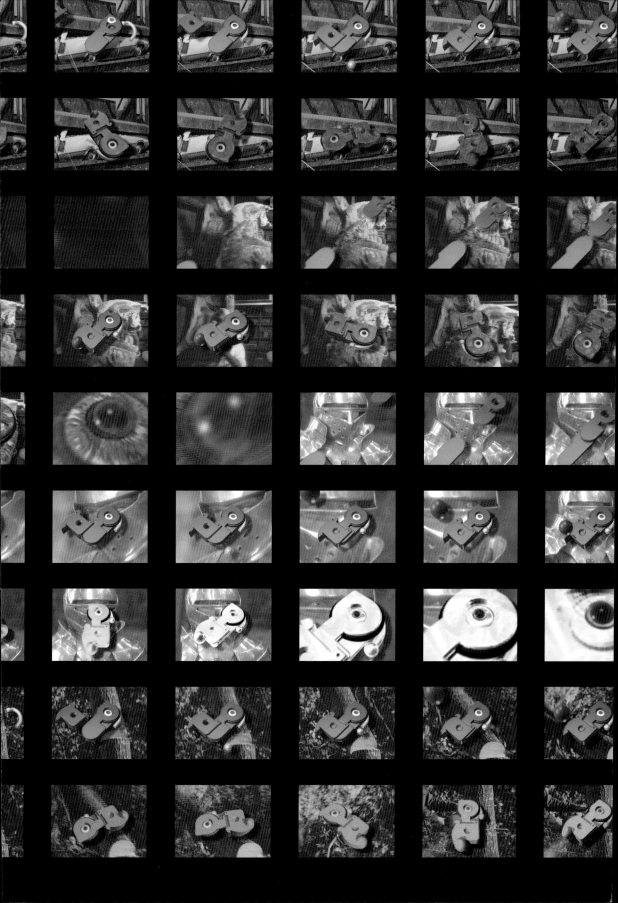

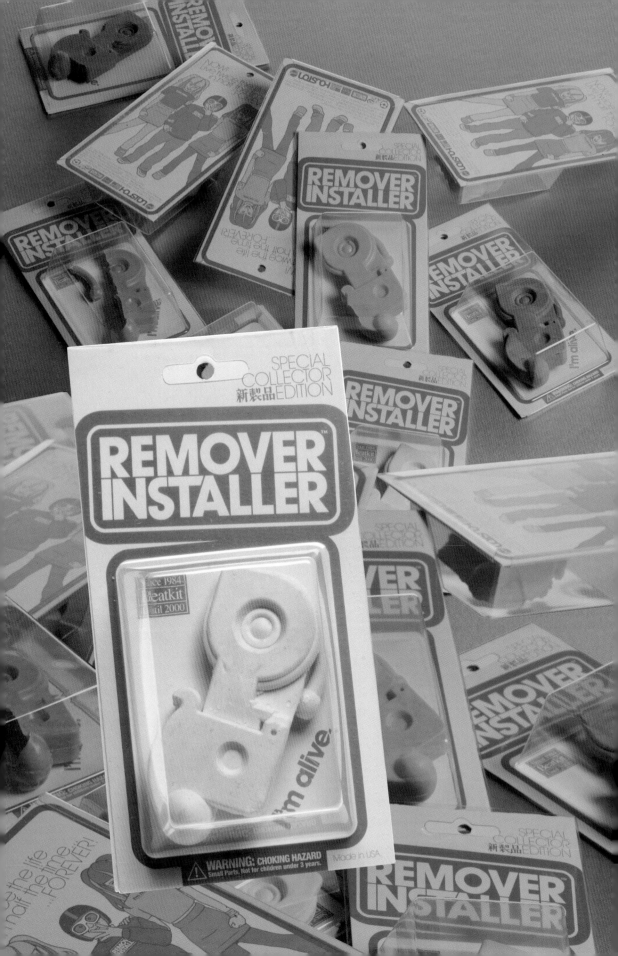

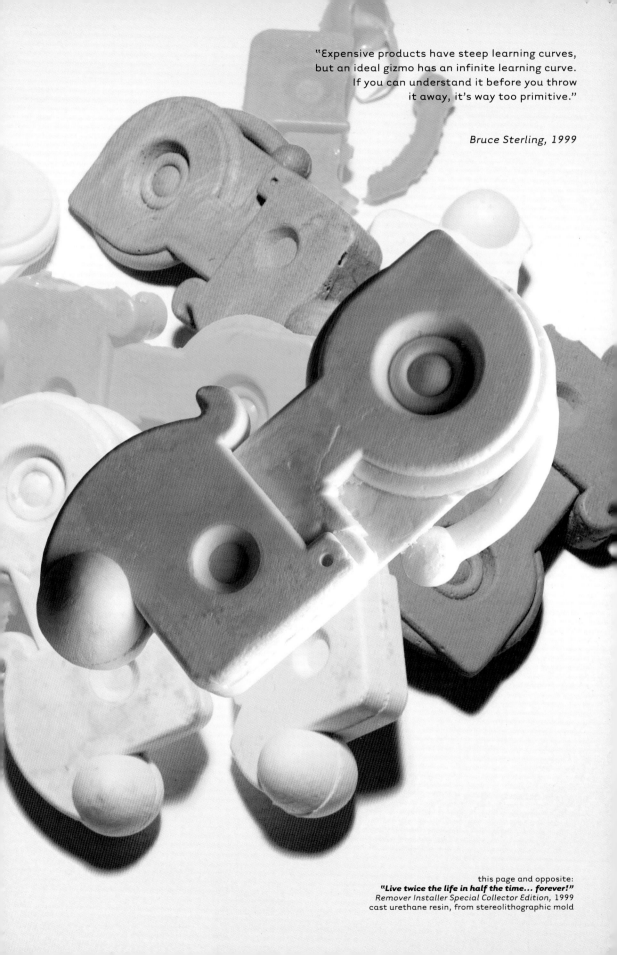

"Expensive products have steep learning curves,
but an ideal gizmo has an infinite learning curve.
If you can understand it before you throw
it away, it's way too primitive."

Bruce Sterling, 1999

this page and opposite:
"Live twice the life in half the time... forever!"
Remover Installer Special Collector Edition, 1999
cast urethane resin, from stereolithographic mold

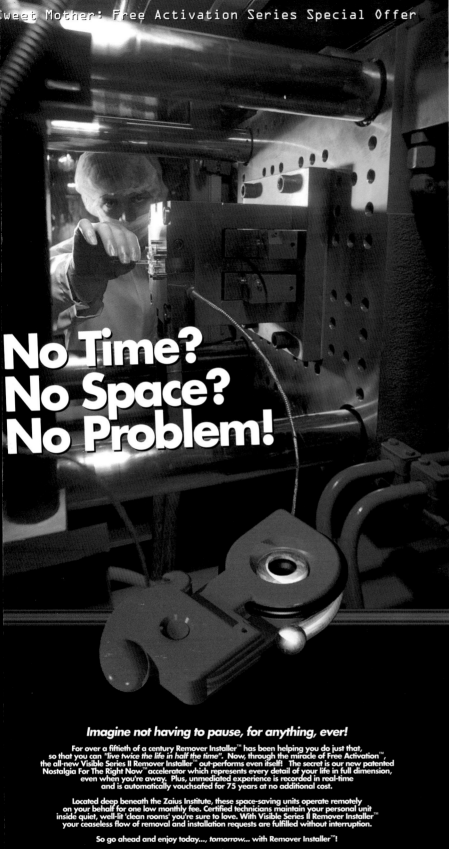

Sweet Mother: Free Activation Series Special Offer

No Time?
No Space?
No Problem!

Imagine not having to pause, for anything, ever!

For over a fiftieth of a century Remover Installer™ has been helping you do just that, so that you can *"live twice the life in half the time".* Now, through the miracle of Free Activation™, the all-new Visible Series II Remover Installer™ out-performs even itself! The secret is our new patented Nostalgia For The Right Now™ accelerator which represents every detail of your life in full dimension, even when you're away. Plus, unmediated experience is recorded in real-time and is automatically vouchsafed for 75 years at no additional cost.

Located deep beneath the Zaius Institute, these space-saving units operate remotely on your behalf for one low monthly fee. Certified technicians maintain your personal unit inside quiet, well-lit 'clean rooms' you're sure to love. With Visible Series II Remover Installer™ your ceaseless flow of removal and installation requests are fulfilled without interruption.

So go ahead and enjoy today..., *tomorrow...* with Remover Installer™!

 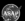

This special offer is made possible with the cooperation of The Sweet Mother Recording Company, AMMA, Beatkit Systems Worldwide, The ASAP Group and The Zaius Institute. Beatkit is an advertisement for its own future uselessnes. For more information on Remover Installer™ and other Beatkit anti-products, visit us at www.zaius.com/zaius.
WARNING: **NOT RECOMMENDED FOR CHILDREN.** If nervousness, sleeplessness or excitability occur, discontinue use and consult a licensed removal professional.

this page:
Free Activation Series
CD insert, 9.5" x 18.5"
Sweet Mother Recordings, 1997

opposite:
Panic Now, Seattle, 1999

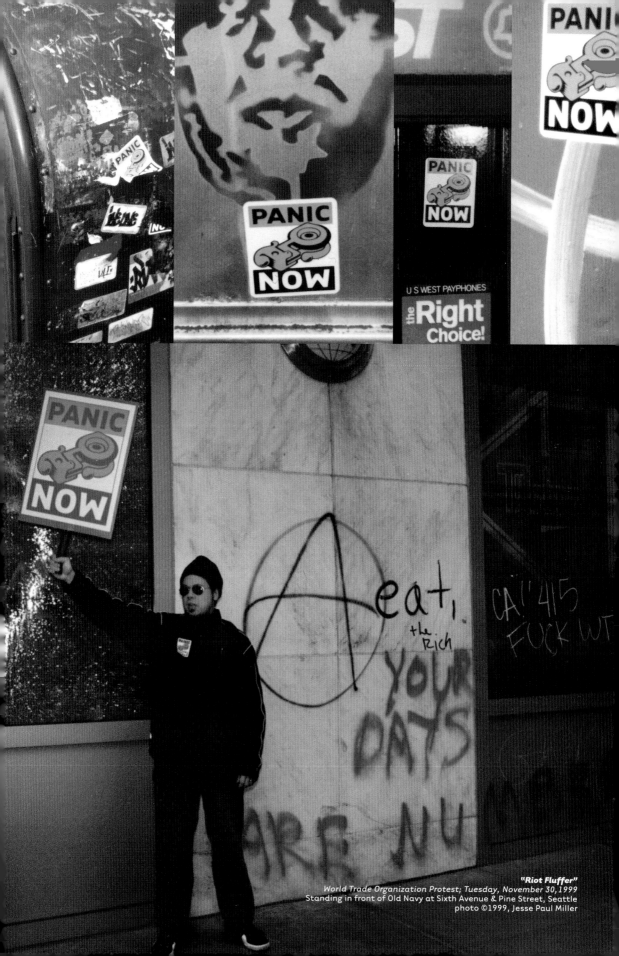

"Riot Fluffer"
World Trade Organization Protest; Tuesday, November 30, 1999
Standing in front of Old Navy at Sixth Avenue & Pine Street, Seattle
photo ©1999, Jesse Paul Miller

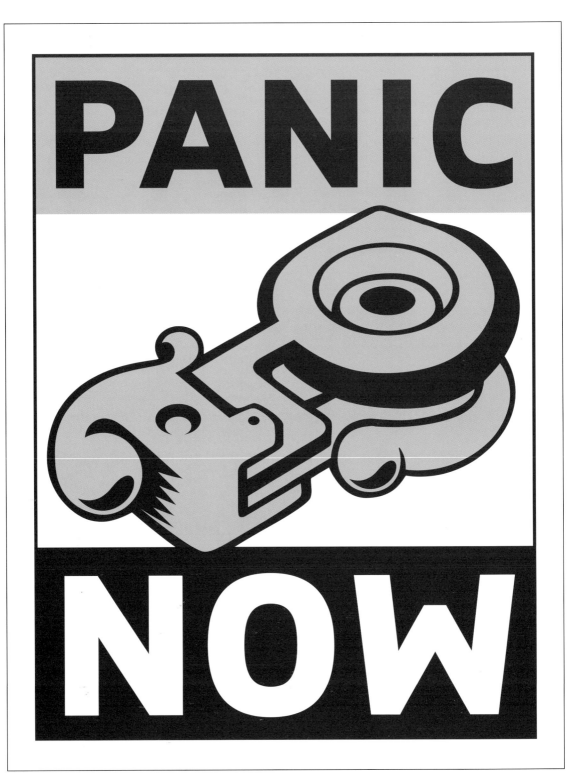

Panic Now Poster
17" x 22" offset
1999

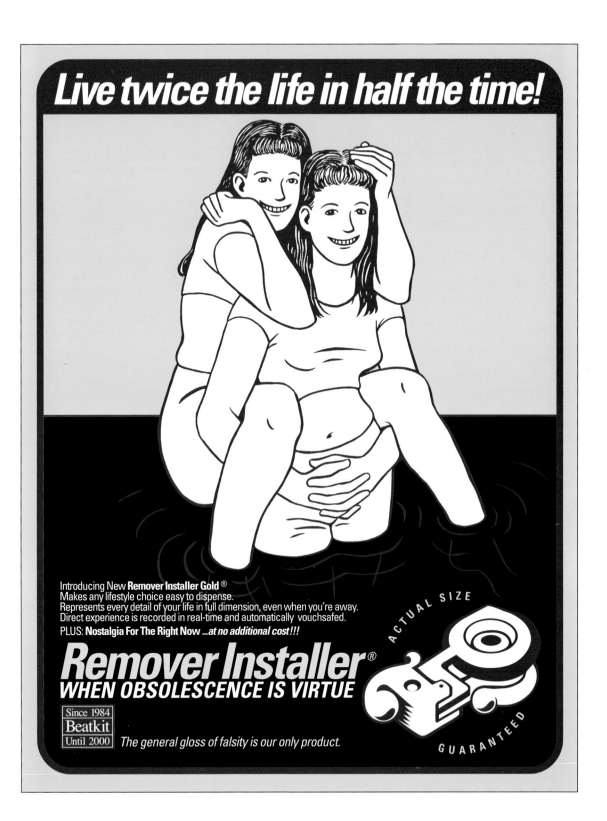

RemoverInstaller Poster
illustration by Ellen Forney
17" x 22" offset
1999

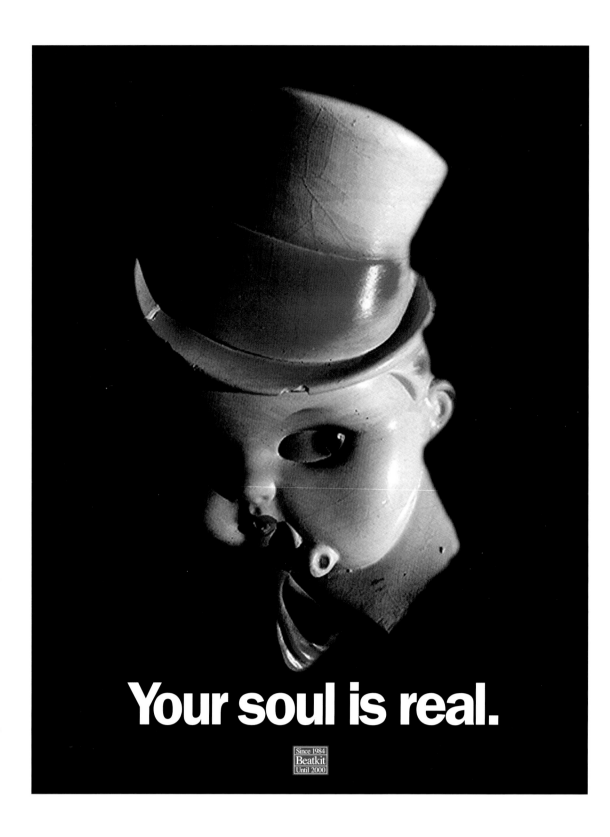

Your Soul Is Real
30" x 40" iris print
1996

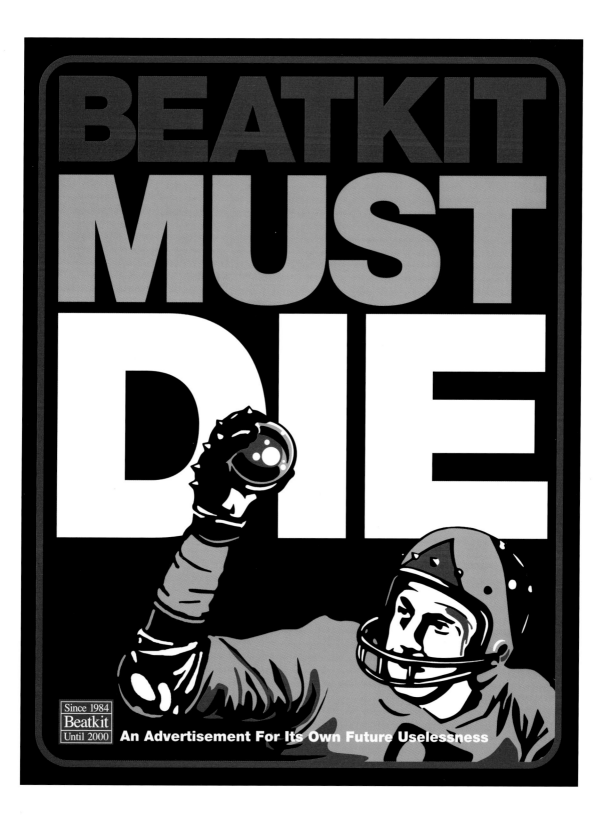

Beatkit Must Die
17" x 22" offset
1999

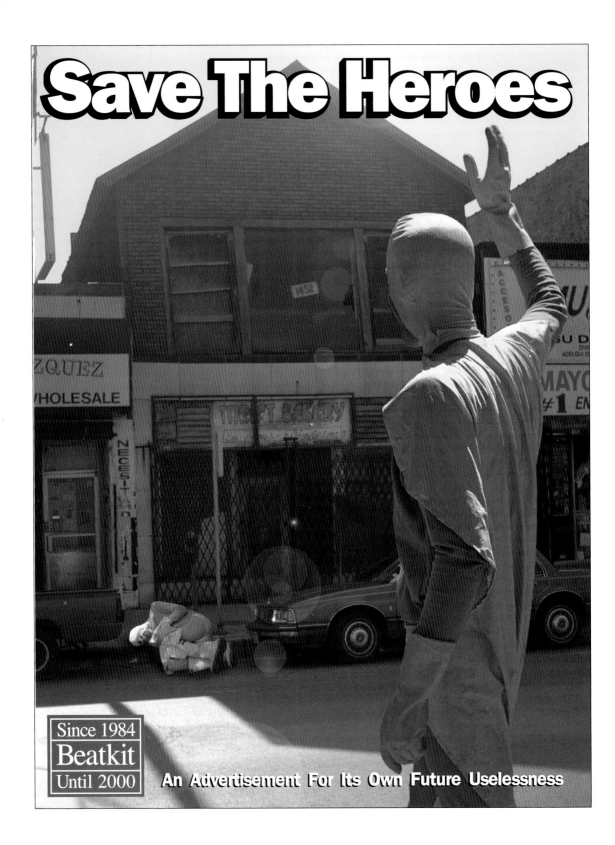

Save The Heroes; The Streets of Chicago
30" x 40" iris print
1997

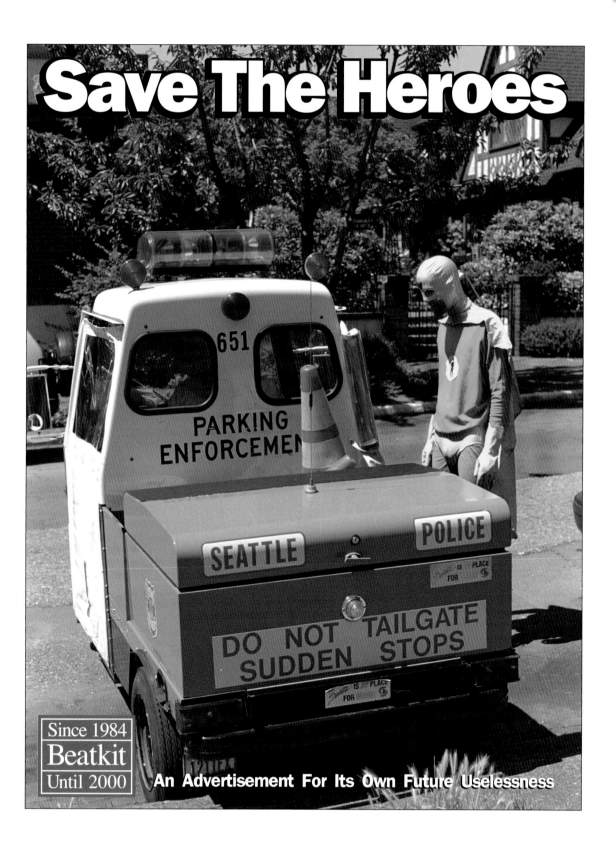

Save The Heroes

651
PARKING
ENFORCEMEN

SEATTLE POLICE

DO NOT TAILGATE SUDDEN STOPS

Since 1984
Beatkit
Until 2000

An Advertisement For Its Own Future Uselessness

Save The Heroes; A Minor Infraction
30" x 40" iris print
1997

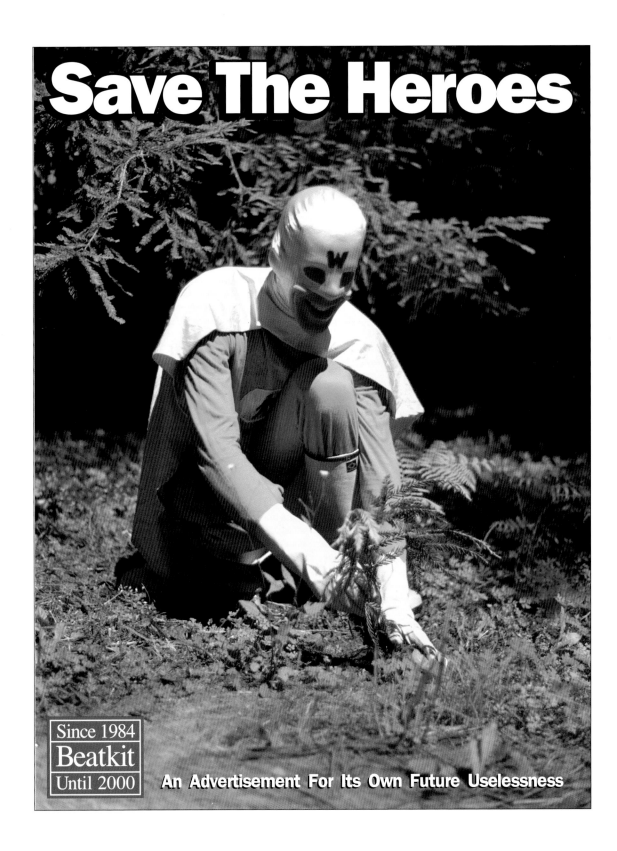

Save The Heroes; Another Do-Gooder
30" x 40" iris print
1997

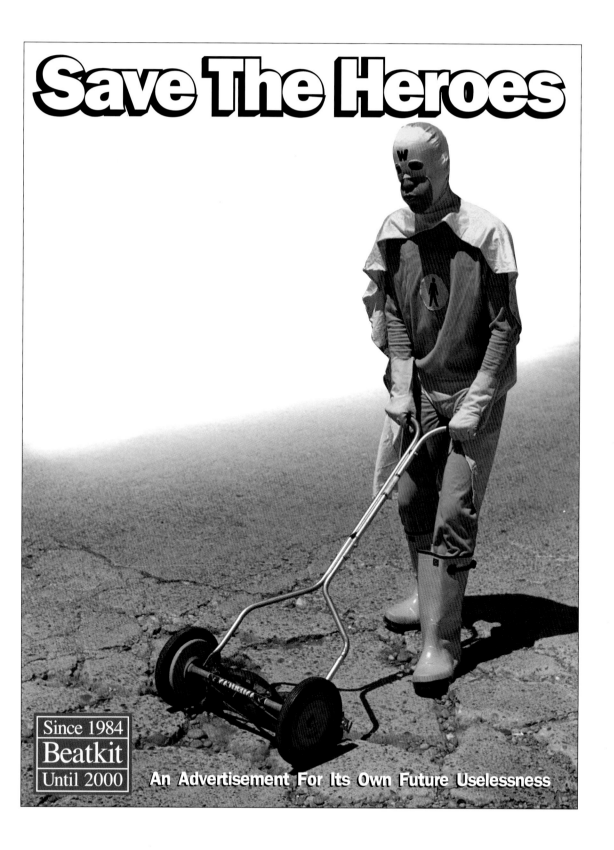

Save The Heroes; Pave The Earth
30" x 40" iris print
1997

The Choice Is Ours.

EXPERTS AGREE

DON'T FORGET

So and So of The Monolab Magazine research team wrote:

"Blah."

The ability they envisioned was available for you yesterday: where were you?

2012

Every Administrator controls his own site.
No one has any real control over any site but his own.
The Administrator gets his power from the owner of the system
he administers, called a Dispatcher. As long as the Dispatcher is
happy with the job the Administrator is doing, he can do whatever he
pleases, up to and including refusing a gateway. After all; to refuse
based on content would jeopardize its legal status as a
Time Specific Available Histories
frame-enhanced service provider.

Order now. Weather can't reach you here.

Since 1984
Beatkit
Until 2000

The Choice Is Ours
30" x 40" iris print
1996

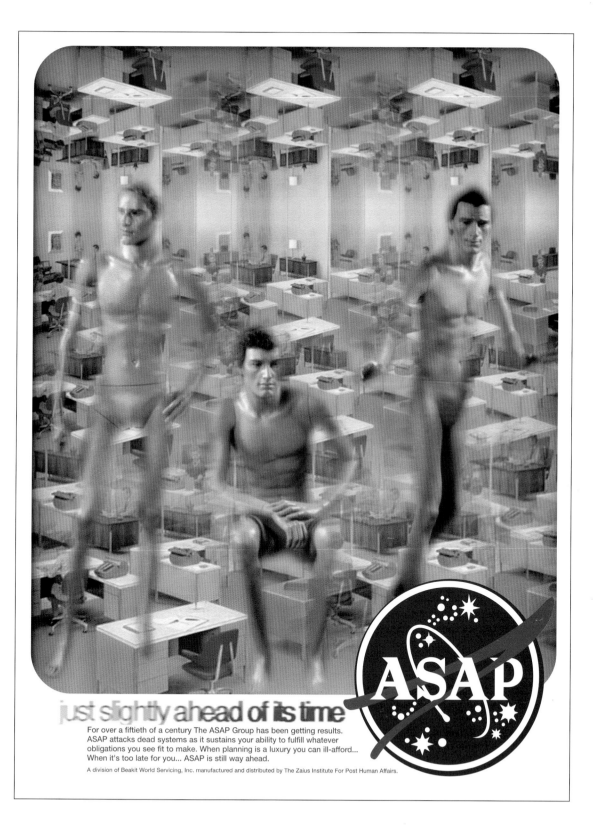

just slightly ahead of its time

For over a fiftieth of a century The ASAP Group has been getting results. ASAP attacks dead systems as it sustains your ability to fulfill whatever obligations you see fit to make. When planning is a luxury you can ill-afford... When it's too late for you... ASAP is still way ahead.

A division of Beakit World Servicing, Inc. manufactured and distributed by The Zaius Institute For Post Human Affairs.

ASAP; Just Slightly Ahead Of Its Time
30" x 40" iris print
1997

Uncanny!

Beatkit's new personal enhancement film is so thin, ...you'll hardly know you're wearing it.

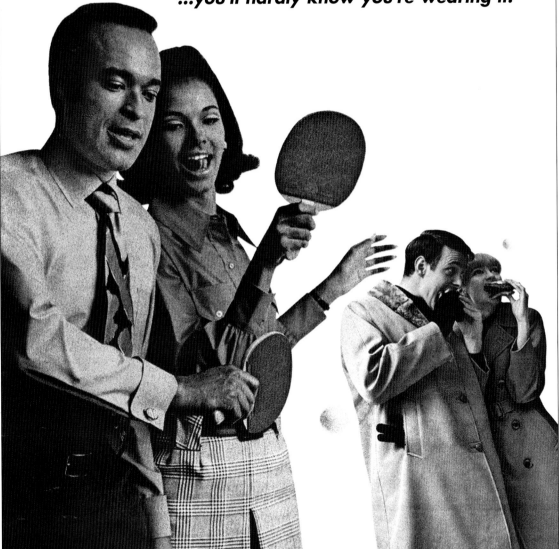

Acme Visible™ is a revealing sheet of waste product you spray on to guard against reflection, penetration and superficial scarring caused by casual eye contact and other forms of exposure. The secret is our patented encapsulation process called "exiling" which masks odors, expressions and any distinguishing marks or characteristics which might otherwise give you away. Acme Visible™ works by actively dulling perception as it gently erases definable features, giving you a relaxed air of sufficiency that others are bound to notice. In today's volatile social scene assimilation is everything, and nothing can alter your personal appearance as imperceptibly as Beatkit homogenizing thin films.

At work, rest or play, Acme Visible™ has you covered.

Since 1984
Beatkit
Until 2000

The general gloss of falsity is our only product.

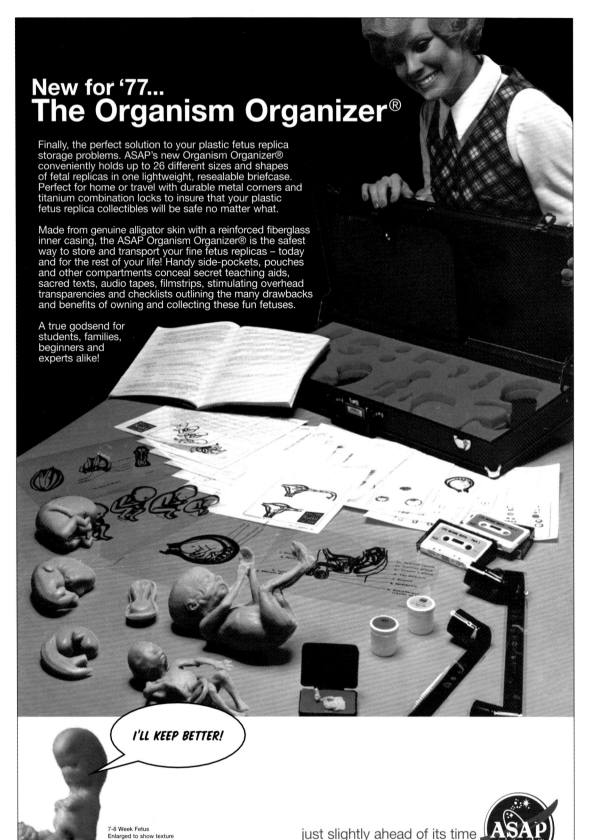

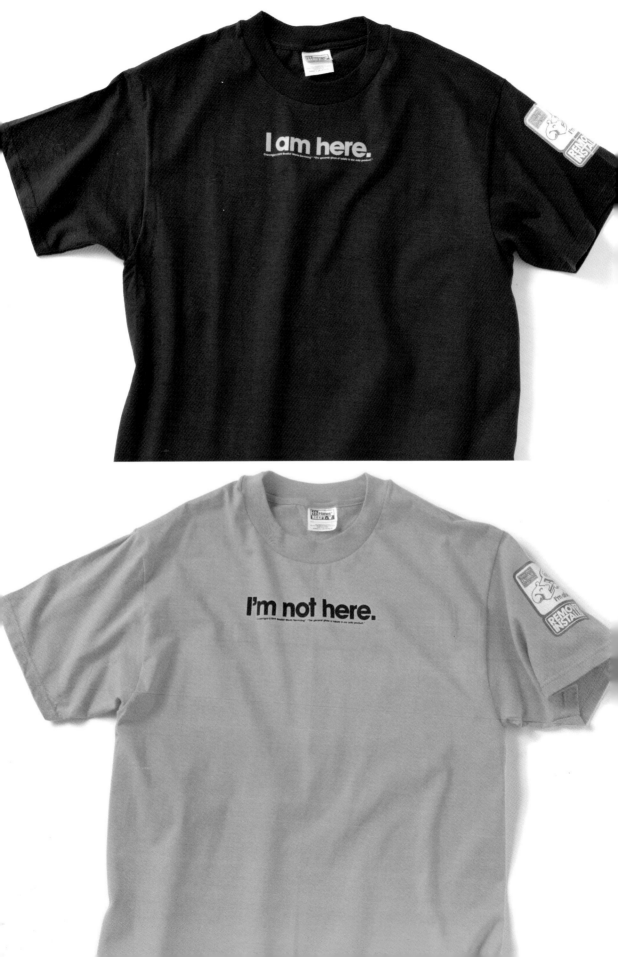

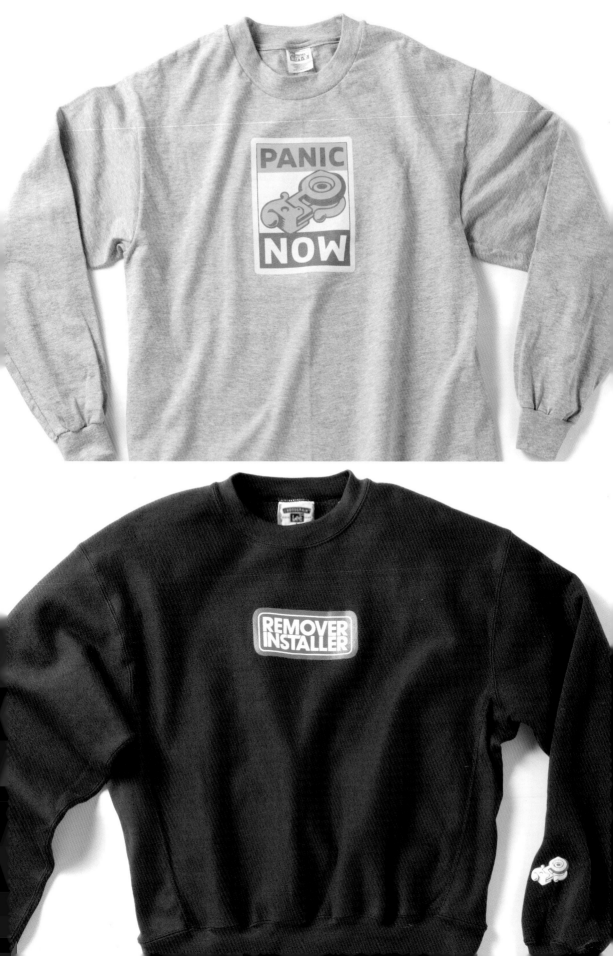

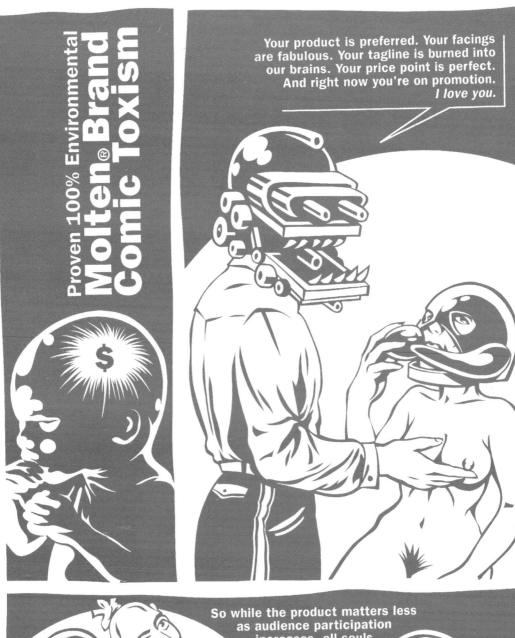
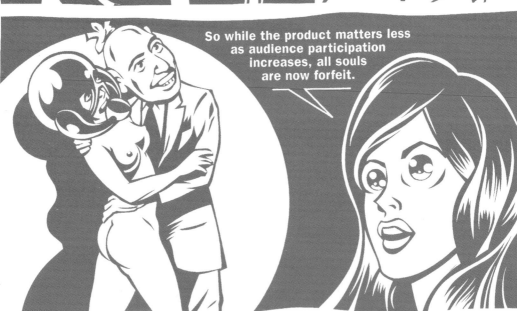

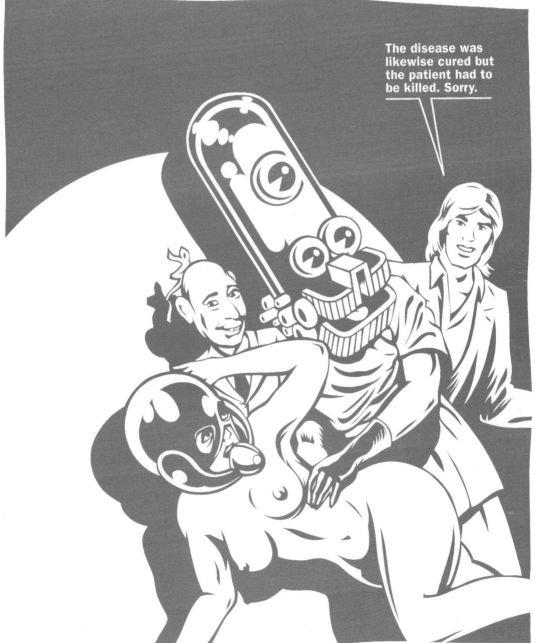

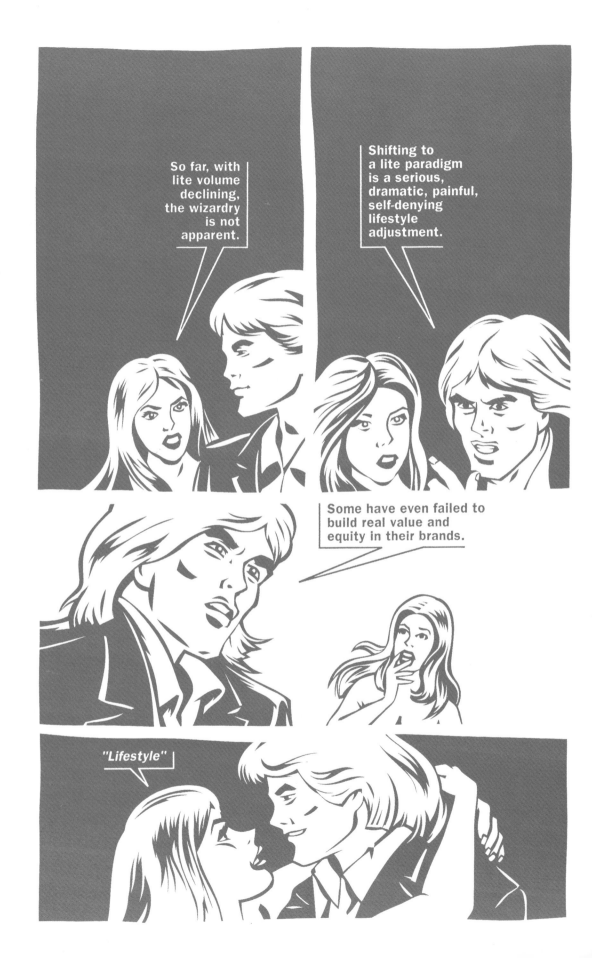

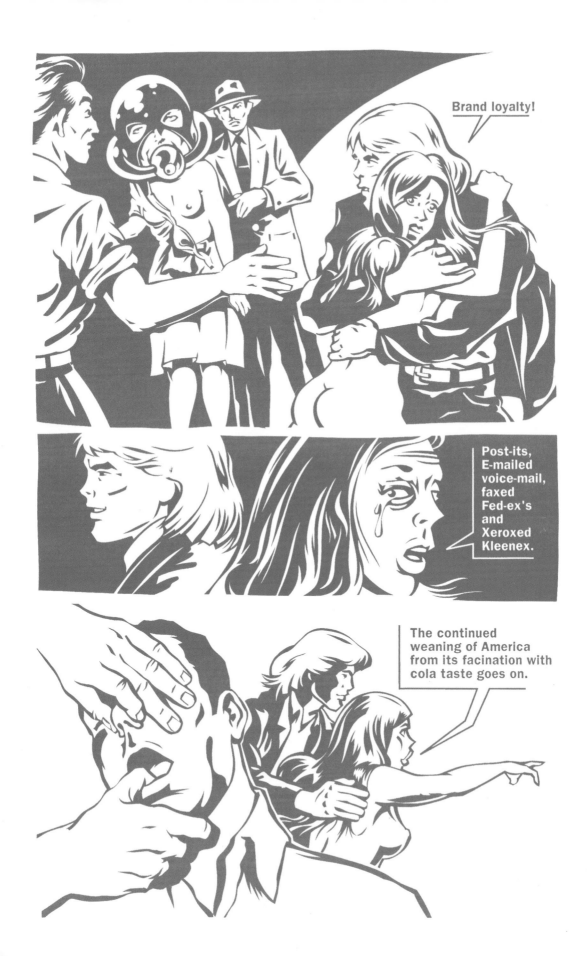

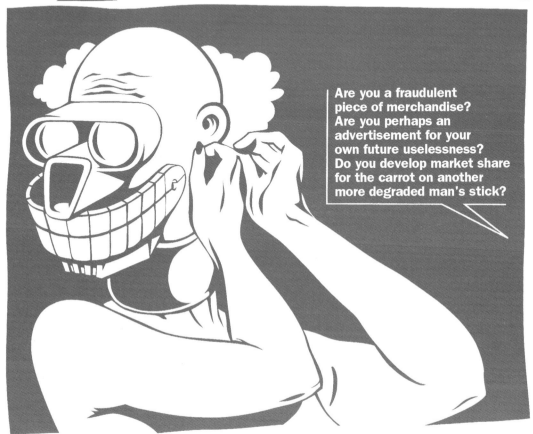

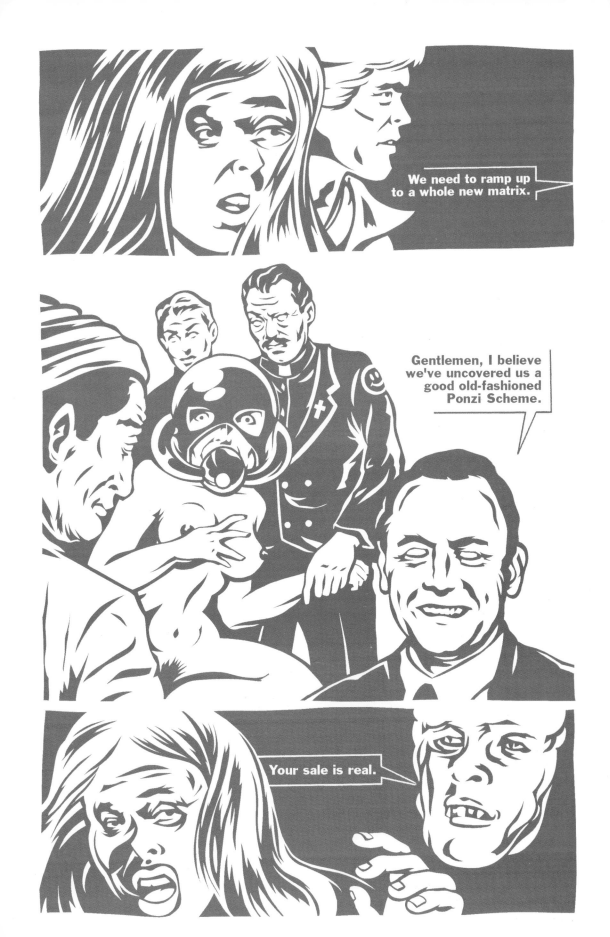

"They were given the choice of becoming kings or the kings' messengers. As is the way with children, they all wanted to be messengers. That is why there are only messengers, racing through the world and, since there are no kings, calling out to each other the messages that have now become meaningless. They would gladly put an end to their miserable life, but they do not dare to do so because of their oath of loyalty." —Franz Kafka, 1918

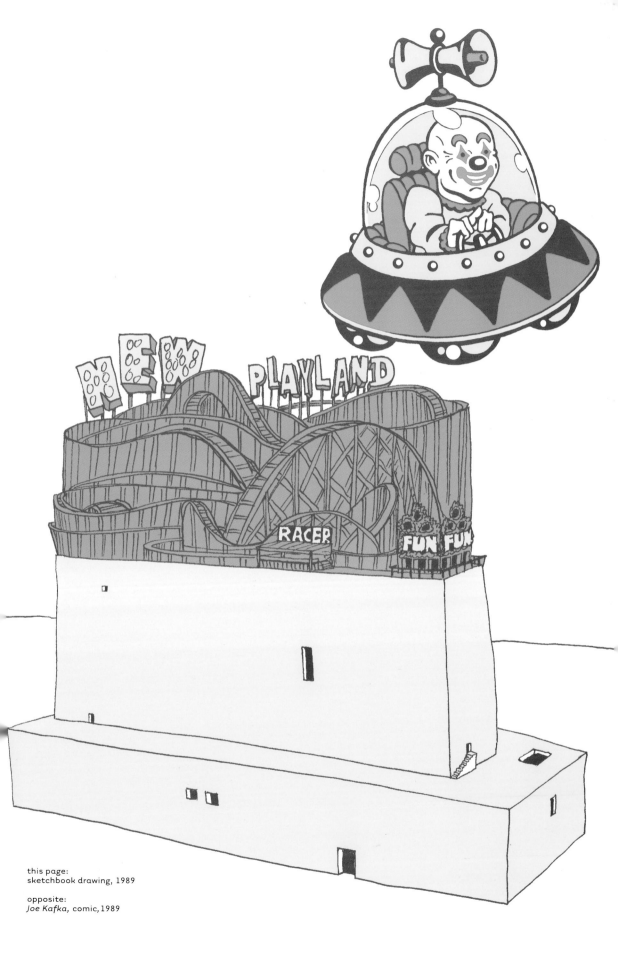

this page:
sketchbook drawing, 1989

opposite:
Joe Kafka, comic, 1989

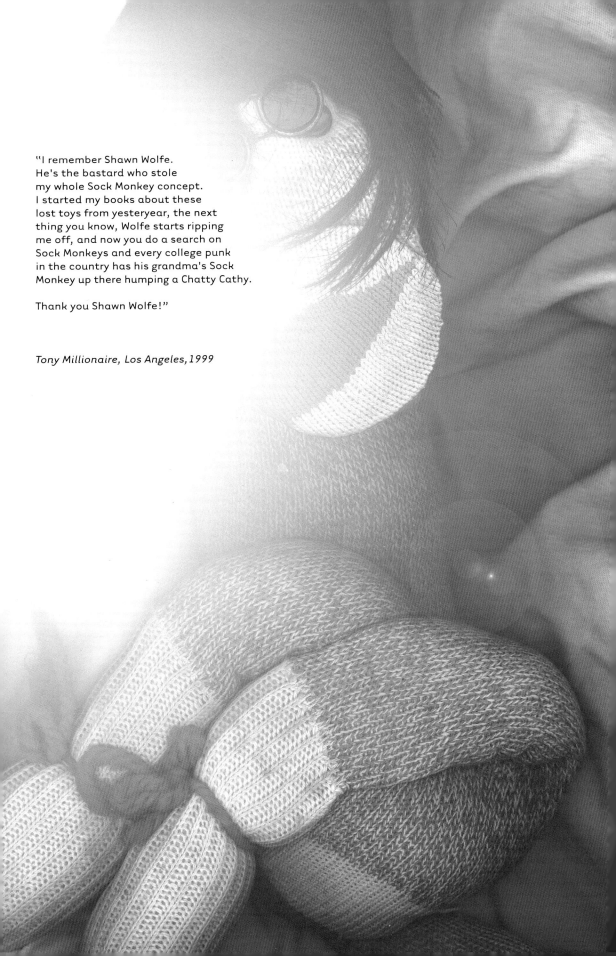

"I remember Shawn Wolfe.
He's the bastard who stole
my whole Sock Monkey concept.
I started my books about these
lost toys from yesteryear, the next
thing you know, Wolfe starts ripping
me off, and now you do a search on
Sock Monkeys and every college punk
in the country has his grandma's Sock
Monkey up there humping a Chatty Cathy.

Thank you Shawn Wolfe!"

Tony Millionaire, Los Angeles, 1999

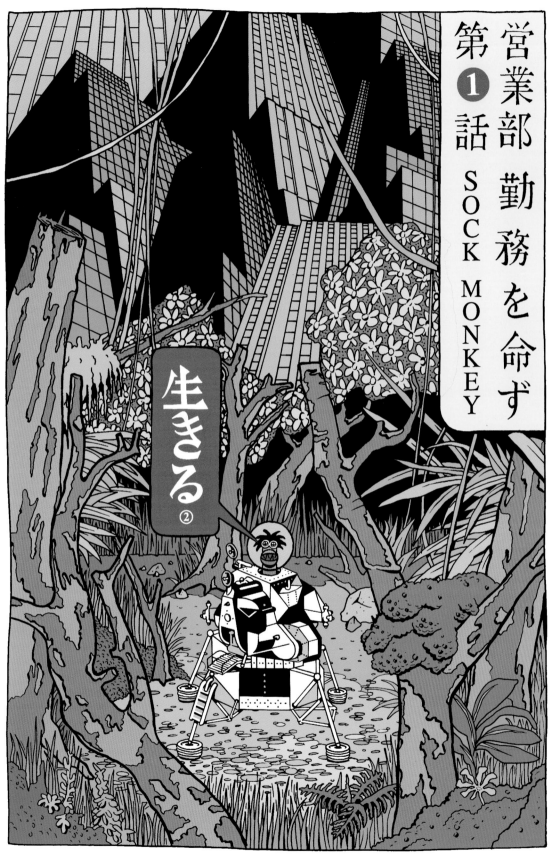

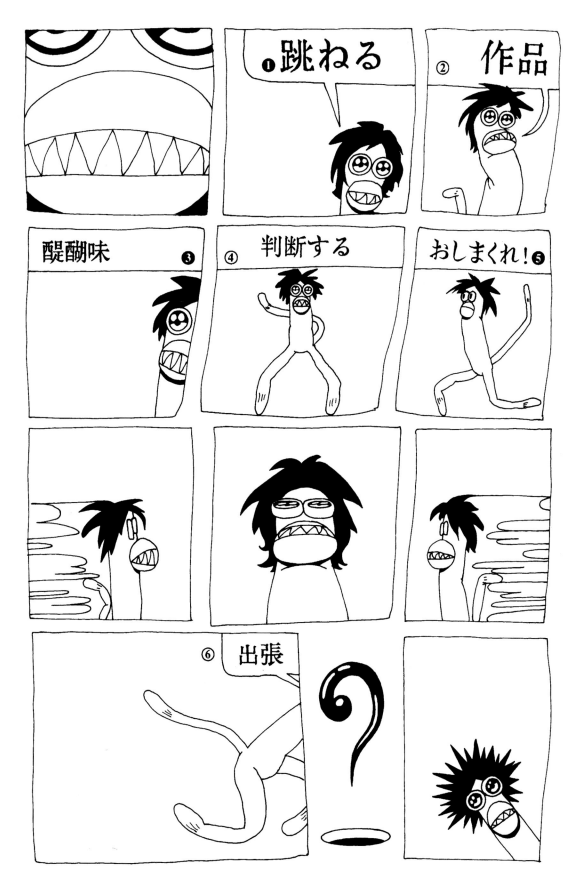

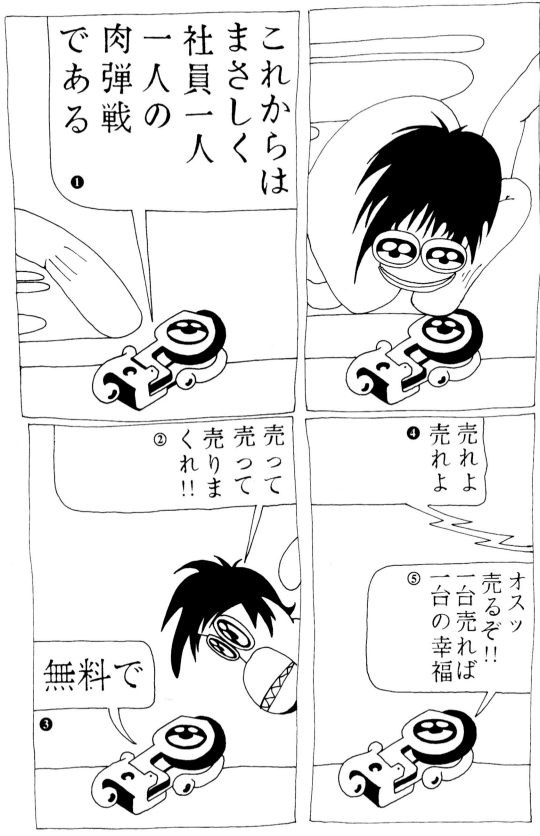

1.WE FACE A TIME WHEN EACH AND EVERY EMPLOYEE MUST LITERALLY THROW HIMSELF INTO THE BATTLE LIKE A HUMAN PROJECTILE. 2.SELL AND SELL AND SELL FOR ALL YOU'RE WORTH!! 3.WITHOUT CHARGE. 4.SELL! SELL!
5.YEAH! SELL!! ONE APPLIANCE SOLD IS ONE APPLIANCE'S WORTH OF HAPPINESS.

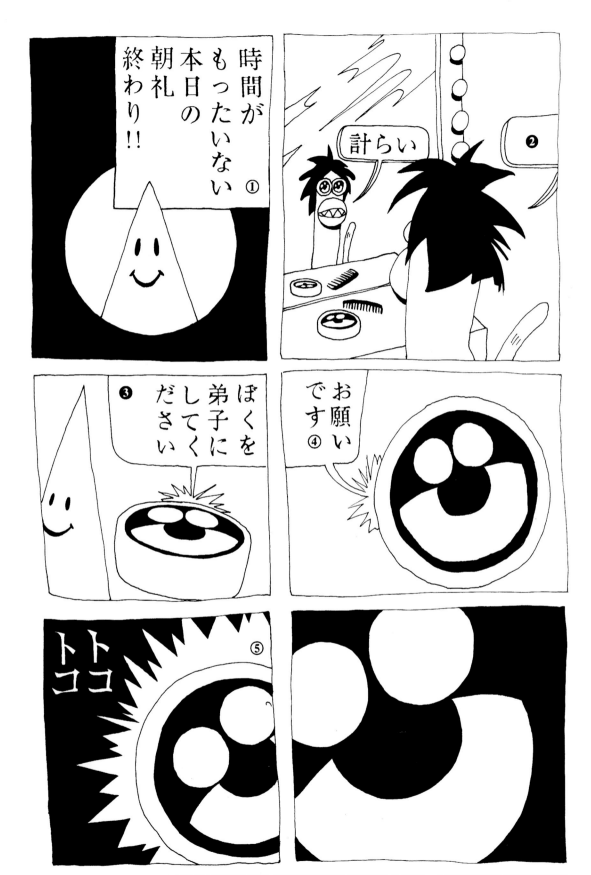

1.WE'RE WASTING TIME. THIS MORNING'S GREETING IS OVER.　2.GOOD OFFICE ARRANGEMENT
3.PLEASE LET ME BE YOUR DISCIPLE!　4.I BEG OF YOU!　5.[THE EFFECT OF WALKING WITH SHORT STEPS]

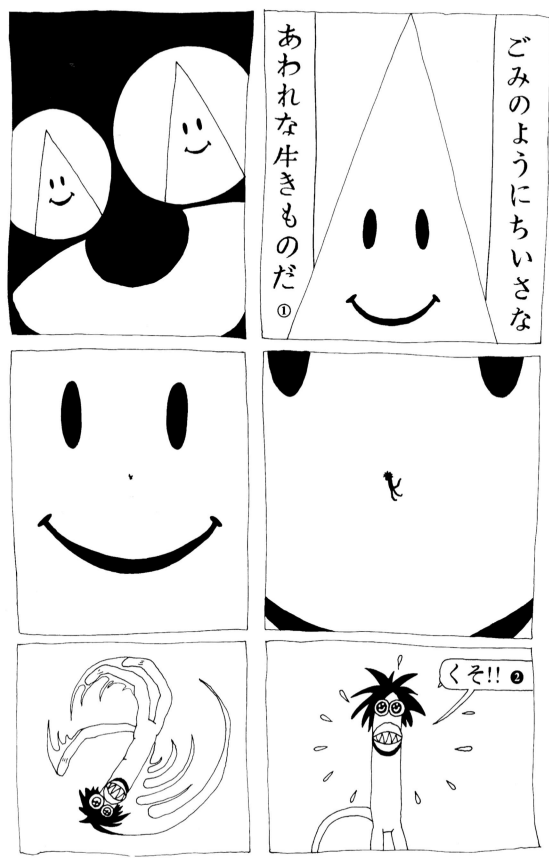

1.YOU ARE A CREATURE AS TINY AND INSIGNIFICANT AS A SPECK OF DUST. 2.FUCK!!

❶ 鋭敏な

② 輝く

③ 細かい

窒息する ❹

❺ 使い

❻ マヌケ

芸術家 ❼

可能 ❽

1.KEEN 2.SPARKLE 3.MINUTE 4.SUFFOCATE 5.MESSENGER 6.IDIOT 7.ARTIST 8.POSSIBILITY

1.TRY DOING IT AS IF YOUR LIFE DEPENDED ON IT, WITHOUT EVEN SLEEPING AT NIGHT. 2.DRY RIVERBED 3.OWNER

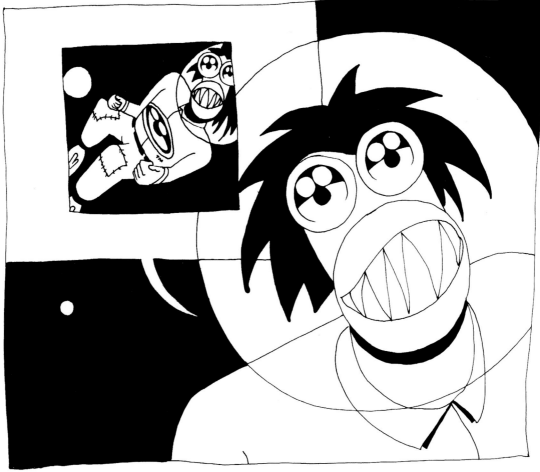

1.WOW. IT'S BEAUTIFUL. IT'S BEAUTIFUL.

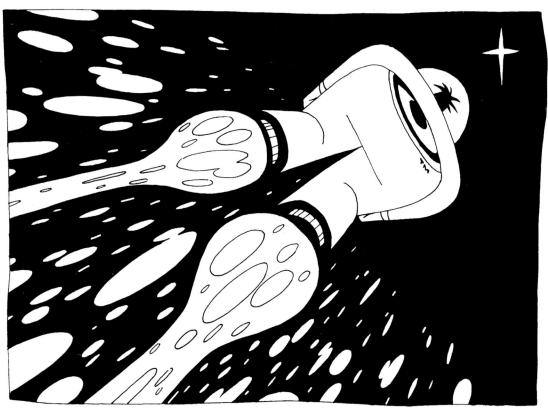

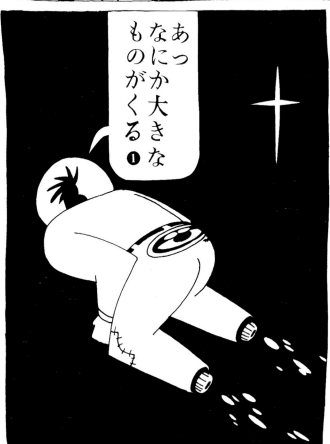

1. OH NO! SOMETHING BIG IS COMING. 2. GULP.

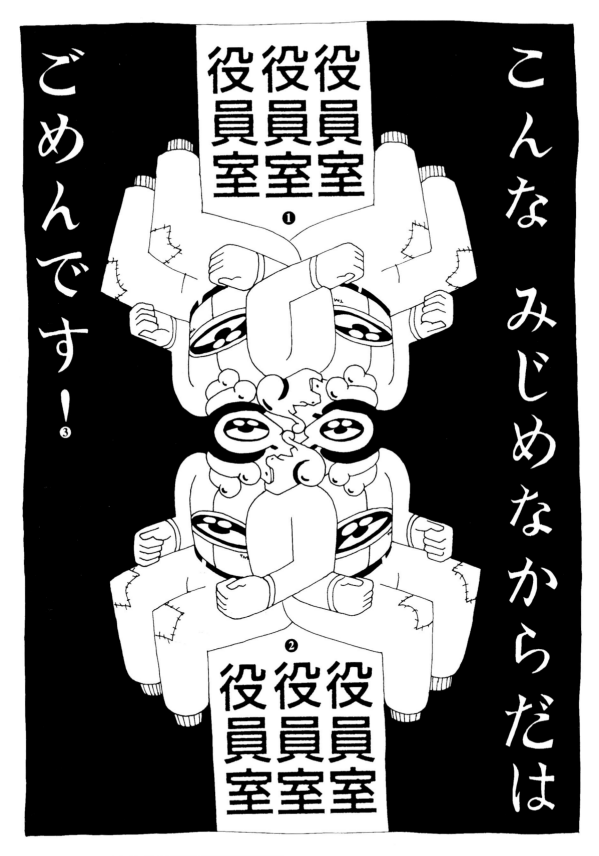

1.EXECUTIVE OFFICES EXECUTIVE OFFICES EXECUTIVE OFFICES
2.EXECUTIVE OFFICES EXECUTIVE OFFICES EXECUTIVE OFFICES
3.THERE'S NO WAY I CAN ACCEPT A MISERABLE BODY LIKE THIS!

審査

❷ 御新
物製
品

③ 会社　の　同僚　の　出張みやげ

1.EXAMINATION 2.NEW PRODUCTS IMPERIAL TREASURES
3.THIS IS A GIFT SOMEONE AT WORK BROUGHT BACK FROM A BUSINESS TRIP.

あ時計が止まってる

こぼれる生まれ変わる

1.OH, MY WATCH HAS STOPPED. 2.GET SPILLED/BE REBORN
3.I'M STILL ALIVE. I THINK I'LL TRY A DIFFERENT MACHINE 4.THANK YOU.

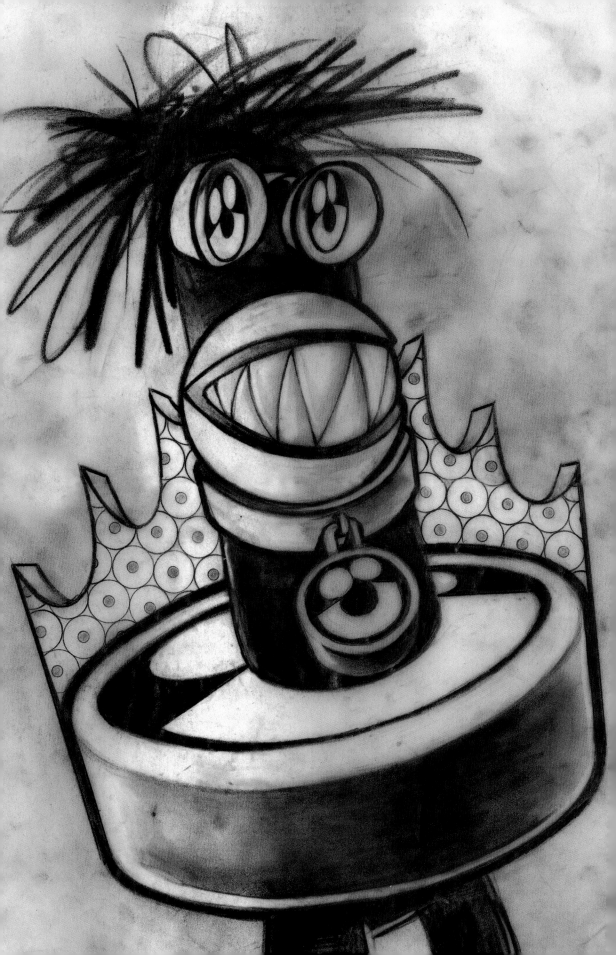

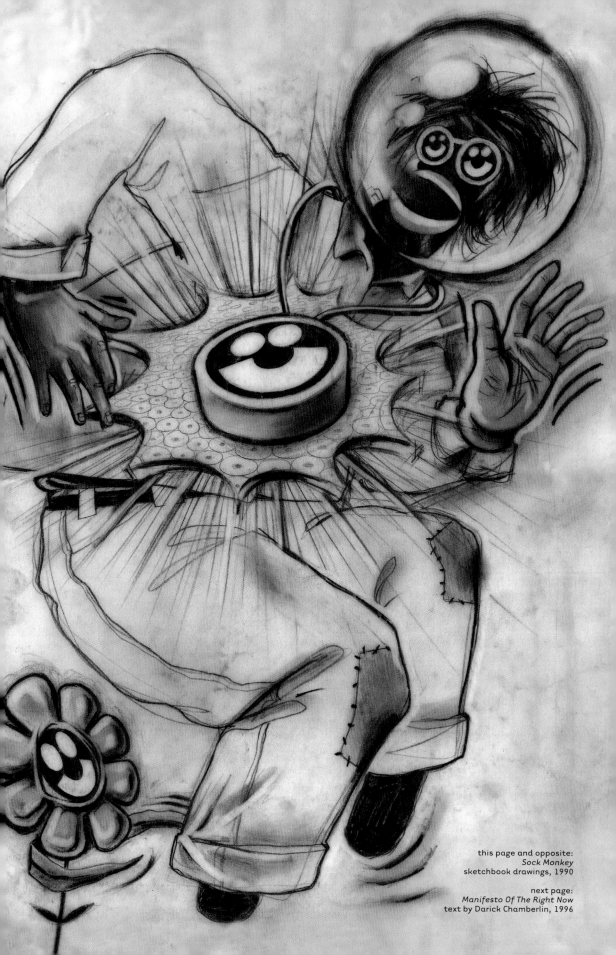

this page and opposite:
Sock Monkey
sketchbook drawings, 1990

next page:
Manifesto Of The Right Now
text by Darick Chamberlin, 1996

Bombardment-of- Homog

UNOFFICIAL FIRST TERRESTRIAL

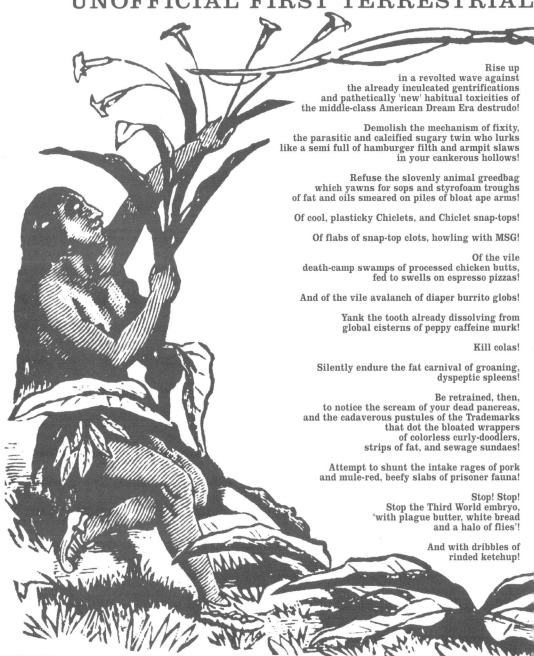

Rise up
in a revolted wave against
the already inculcated gentrifications
and pathetically 'new' habitual toxicities of
the middle-class American Dream Era destrudo!

Demolish the mechanism of fixity,
the parasitic and calcified sugary twin who lurks
like a semi full of hamburger filth and armpit slaws
in your cankerous hollows!

Refuse the slovenly animal greedbag
which yawns for sops and styrofoam troughs
of fat and oils smeared on piles of bloat ape arms!

Of cool, plasticky Chiclets, and Chiclet snap-tops!

Of flabs of snap-top clots, howling with MSG!

Of the vile
death-camp swamps of processed chicken butts,
fed to swells on espresso pizzas!

And of the vile avalanch of diaper burrito globs!

Yank the tooth already dissolving from
global cisterns of peppy caffeine murk!

Kill colas!

Silently endure the fat carnival of groaning,
dyspeptic spleens!

Be retrained, then,
to notice the scream of your dead pancreas,
and the cadaverous pustules of the Trademarks
that dot the bloated wrappers
of colorless curly-doodlers,
strips of fat, and sewage sundaes!

Attempt to shunt the intake rages of pork
and mule-red, beefy slabs of prisoner fauna!

Stop! Stop!
Stop the Third World embryo,
'with plague butter, white bread
and a halo of flies'!

And with dribbles of
rinded ketchup!

IRON CLAD DECADENC

This public service announcement is made on behalf of The Zaius Foundation For Post Human Affairs, a

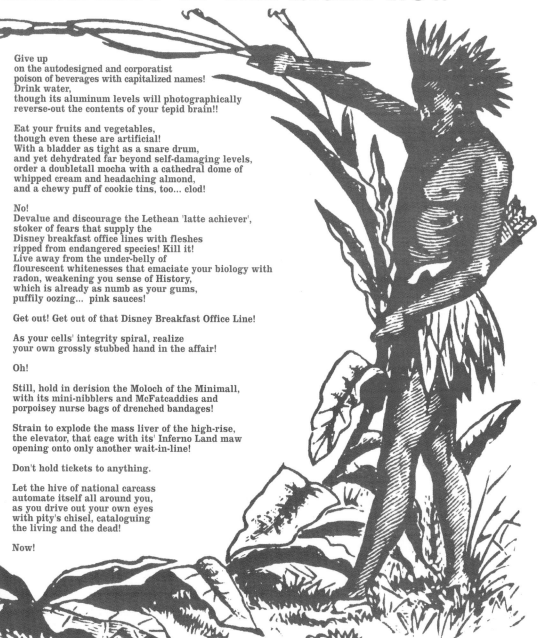

Give up
on the autodesigned and corporatist
poison of beverages with capitalized names!
Drink water,
though its aluminum levels will photographically
reverse-out the contents of your tepid brain!!

Eat your fruits and vegetables,
though even these are artificial!
With a bladder as tight as a snare drum,
and yet dehydrated far beyond self-damaging levels,
order a doubletall mocha with a cathedral dome of
whipped cream and headaching almond,
and a chewy puff of cookie tins, too... clod!

No!
Devalue and discourage the Lethean 'latte achiever',
stoker of fears that supply the
Disney breakfast office lines with fleshes
ripped from endangered species! Kill it!
Live away from the under-belly of
flourescent whitenesses that emaciate your biology with
radon, weakening you sense of History,
which is already as numb as your gums,
puffily oozing... pink sauces!

Get out! Get out of that Disney Breakfast Office Line!

As your cells' integrity spiral, realize
your own grossly stubbed hand in the affair!

Oh!

Still, hold in derision the Moloch of the Minimall,
with its mini-nibblers and McFatcaddies and
porpoisey nurse bags of drenched bandages!

Strain to explode the mass liver of the high-rise,
the elevator, that cage with its' Inferno Land maw
opening onto only another wait-in-line!

Don't hold tickets to anything.

Let the hive of national carcass
automate itself all around you,
as you drive out your own eyes
with pity's chisel, cataloguing
the living and the dead!

Now!

F AUTHORITY OATHS

ENTROPYMAN

THE GREATEST BATMAN STORIES ON EARTH THAT HAVE EVER BEEN TOLD ARE BEING TOLD TO YOU RIGHT NOW! BY ME!

MADE YOU LOOK!!!

REMEMBER, I WENT TO BAT FOR YOU.

I WILL GIVE YOU A FEW SECONDS TO RUN... BUT I WILL CATCH YOU, AND YOU WILL DIE.

I WAS ONCE ASKED TO DEVISE THE ULTIMATE SEX-DEATH OF RONALD REAGAN.

IN THE VERY NEAR FUTURE ALL STORES WILL FEATURE SIX IN-STORE SUPERSTORES.

THIS IS AN ATTEMPT TO COLLECT A DEBT.

ANY INFORMATION OBTAINED WILL BE USED FOR THAT PURPOSE.

The Lighter Side Of

Panic!

this page:
The Lighter Side of Panic
bOING bOING magazine, 1995

opposite:
Entropy Man
text by Darick Chamberlin & Shawn Wolfe, 1991

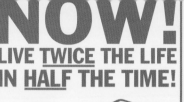
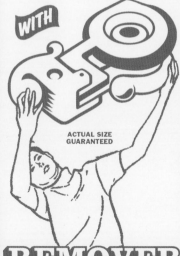

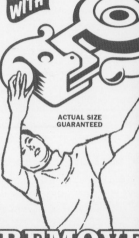

PROTO
TYPE

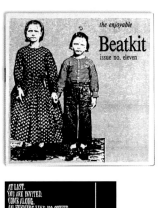

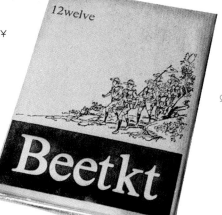

Beatkit Fanzine: 1984–1989
¥ by James Towning
Ω by David Butler
all others by Shawn Wolfe

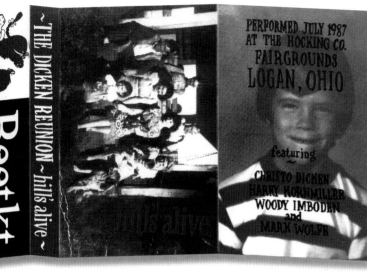

THE DICKEN REUNION ~ hills' alive ~

Beat kit

PERFORMED JULY 1987
AT THE HOCKING CO.
FAIRGROUNDS
LOGAN, OHIO

featuring

CHRISTO DICKEN
HARRY KORNMILLER
WOODY IMBODEN
and
MARK WOLFE

Joe Kafka

TRA LA LA ¥

Since 1984
Beatkit
Until 2000

Joe Kafka
Sock Monkey

Blackberry Black
You Let Me Down
Scarey Head
Naked In The Weeds
Bossy
Marischino Baby
Black Crow Bike Ride
Sweet Sickness
Cool Acid Drop
Please Think Back
Send A Rain
K. I. S. S.
The Weight Of Ezra Pound
Quixote Sunday
Pumpkin Brother
Home Sweet Home
L' Rockhouse Rocker
Disconnected
On The High Road
Car Say
Let's Stand Here
First Down In The Serengeti
Franklin Albert Jones
Hatesexy
Jawbone
Mr. Happy Summer
More
World On My Shoulders
Ten Feet Tall
Seth Sez

It's been a good two years now since we
first took the Fostex up to the abandoned
attic of what was the original Face 22 Inc.
Corporate Headquarters for the historic first
jam sessions. We didn't even know Sock
Monkey back then! (I often wonder how life
would be different if only we had...) It's nice
to look back on everything though and know
that all of the success and adulation hasn't
changed any of us in the slightest. If
anything, we are more people today than we
were two years ago.

Take this tape on vacation with you this
summer and think of us when you listen to it.
All of the songs are truly engi moking, with
the exception of 'Please Think Back' (written
by John "Way Bald" Walsh) and 'Ten Feet Tall'
(*Classic New Wave* by xtc).

Until next time...if there is a next time...if
we run so steady...if Franklin Albert Jones is
still alive...if we're disconnected...if the dawn
breaks...the morning dishes...remember, it's
because of you.

Sincerely,
Joe Kafka

Since 1984
Beatkit
Until 2000

Copyright 1987 Beatkit. All rights reserved.

¥

LITTLE PARTY
WITH A RCK' BAND

BEAT KIT RECORDS 1984

SEND COMMENTS AND ...
INQUIRIES TO
BEAT KIT PUBLICATIONS
597 FRANKLIN/3
COLS. OH. 43215

UN-HANDSOMELY.
AT ONCE KENNY'S
EYE WAS BIG,
SAW THROUGH THAT
SOLID OBSTACLE
SOLID, JACKSON!

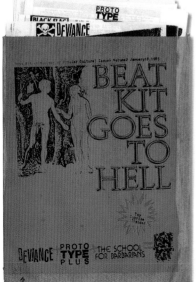

PROTO
TYPE

BLACK FLAG

DEVIANCE

BEAT
KIT
GOES
TO
HELL

DEVIANCE PROTO
TYPE
PLUS

THE SCHOOL
FOR BARBARIANS

POP THEORY
FROM THE
BOWELS OF HECK

3002

BEAT KIT JUNE 22,1984

BEAT KIT

bottoms up

Presenting an old favorite.

Uncle Milo's Old Fashioned Grape Juice Plus®
takes you to the Forbidden Zone and beyond.
From bush to the treetop to the far reaches of
time and space, Grape Juice Plus® has been
putting the sizzle in simian society for ages.

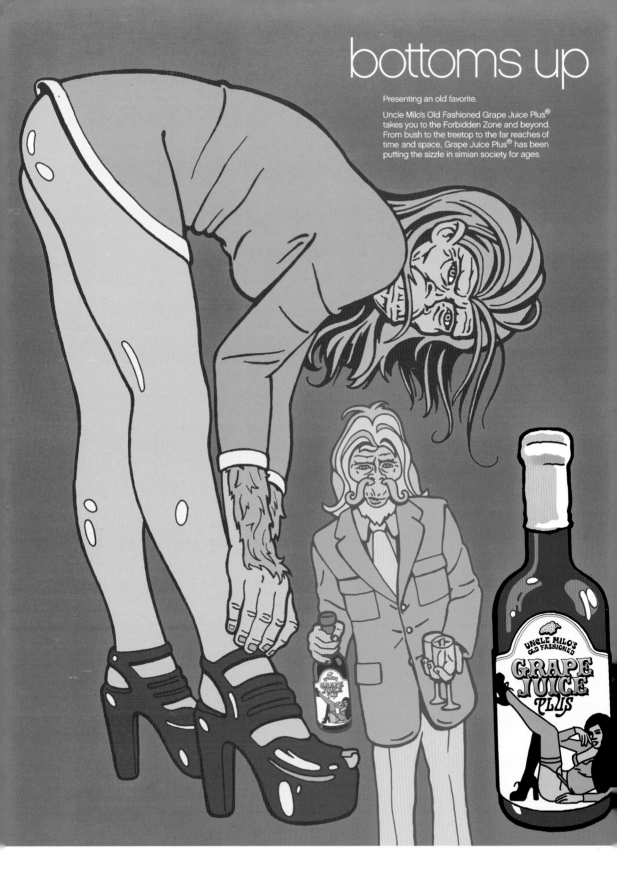

Bottoms Up
First appeared in *House* magazine,
marking the release of their 'Simian' font
2001

Motel Fez, postcard illustration
Fez, 1999

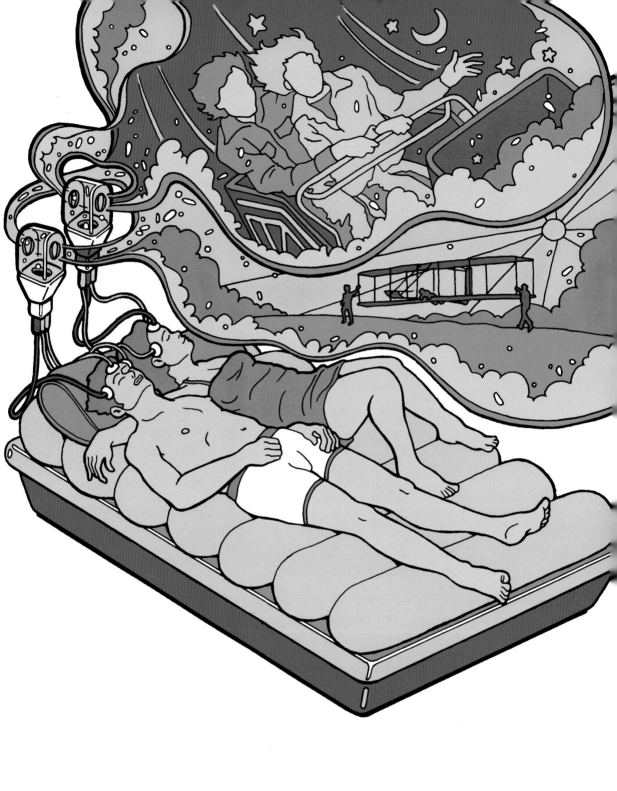

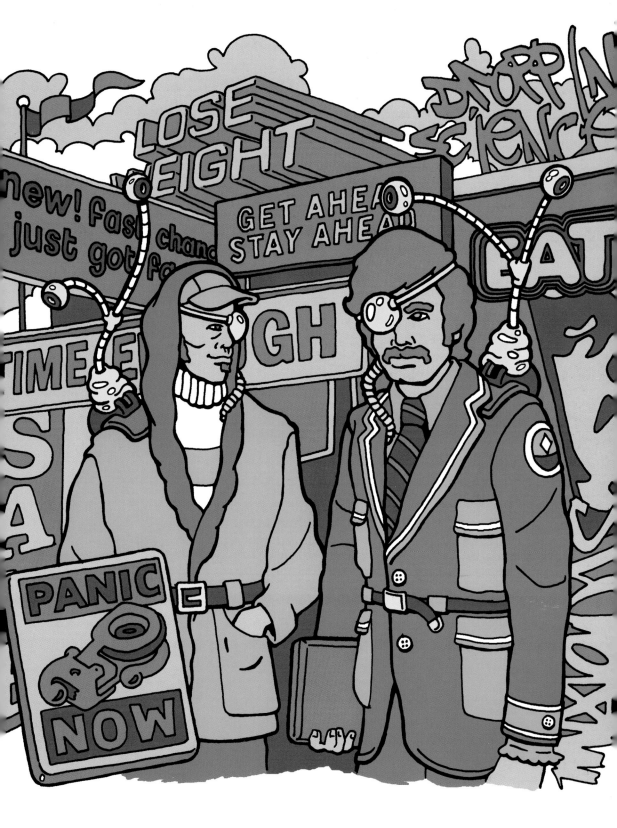

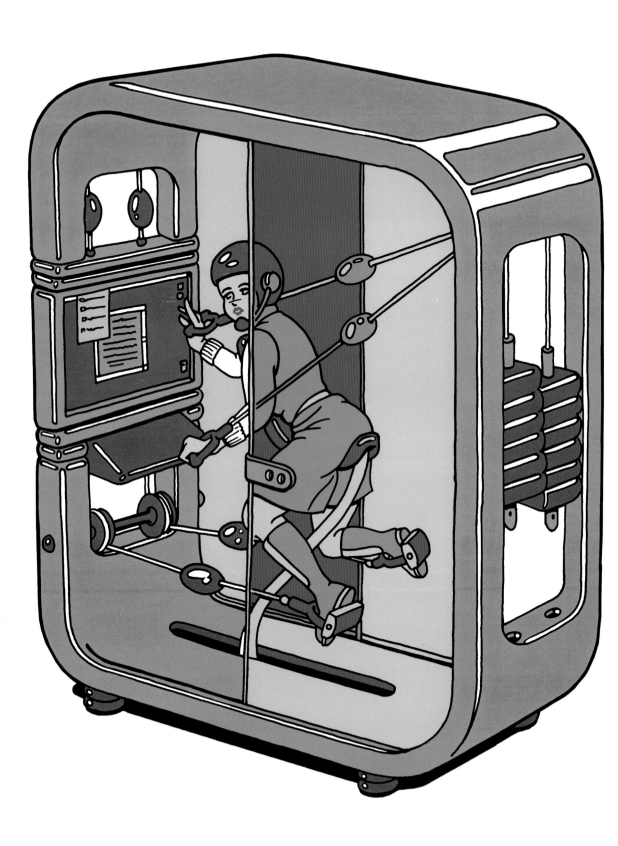

this spread:
Future Inventions
Metropolis, 2001

Beastie Boys, editorial illustration
The Rocket, 1998

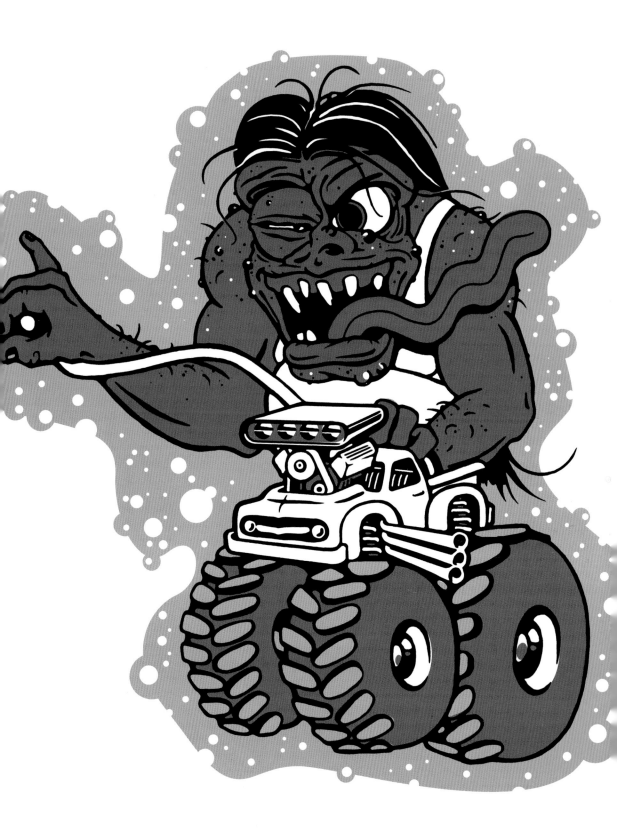

Monster Truck Monster
The Stranger, 1998

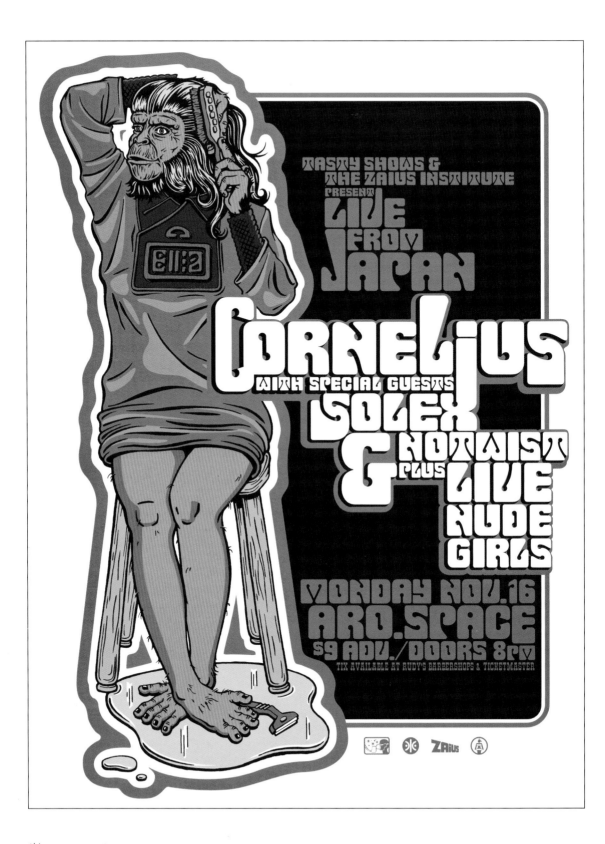

this page:
Cornelius, event poster
ARO.space, 1998

opposite:
Sneaker Pimps, event poster
Tasty Shows, 1997

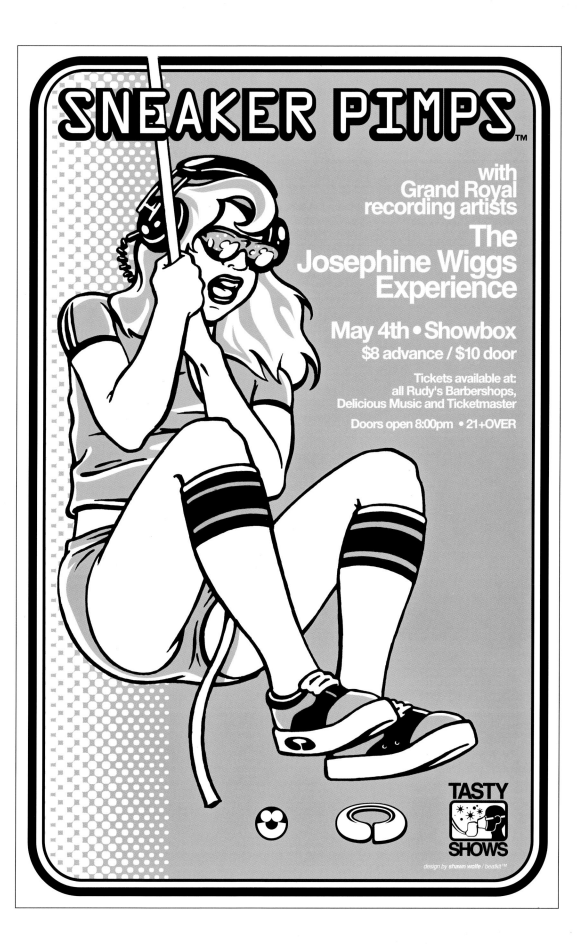

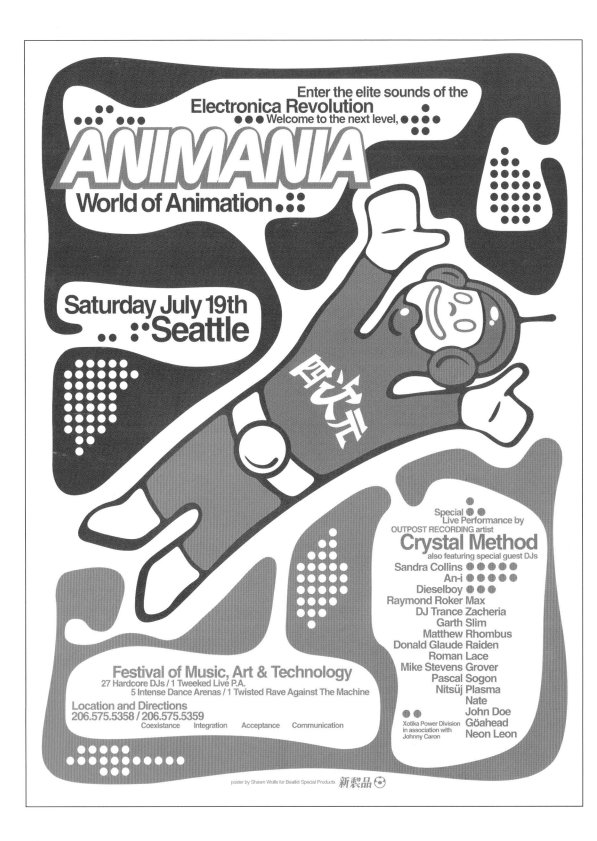

this page:
Animania, event poster
Caron Productions, 1997

opposite:
Meat Beat Manifesto, event poster
Tasty Shows, 1996

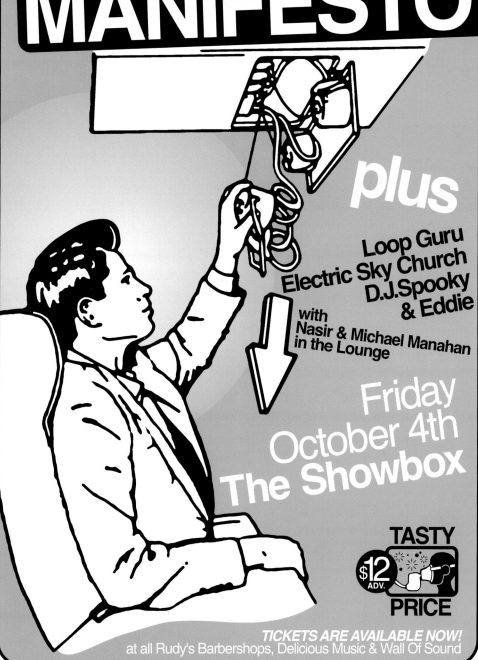

Tasty Shows & Sweet Mother Recordings Invite You to
A Very Special **Electrolush** with

MEAT BEAT MANIFESTO

plus

Loop Guru
Electric Sky Church
D.J.Spooky
& Eddie

with
Nasir & Michael Manahan
in the Lounge

Friday
October 4th
The Showbox

TASTY

$12 ADV.

PRICE

TICKETS ARE AVAILABLE NOW!
at all Rudy's Barbershops, Delicious Music & Wall Of Sound

Mad Professor, event handbill
Tasty Shows, 1998

Tasty Shows and 360BPM get live with

Goldie

PERFORMING LIVE!
w/special guests
AG Zilla
and Sweet Mother Recordings artist
Nasir in the lounge

Saturday December 6 / Showbox / $15 adv.
Tickets available at Ticket Masters and all Rudy's. Barbershops
DESIGN BY SHAWN WOLFE COURTESY BEATKIT MFG.

Goldie, event handbill
Tasty Shows, 1998

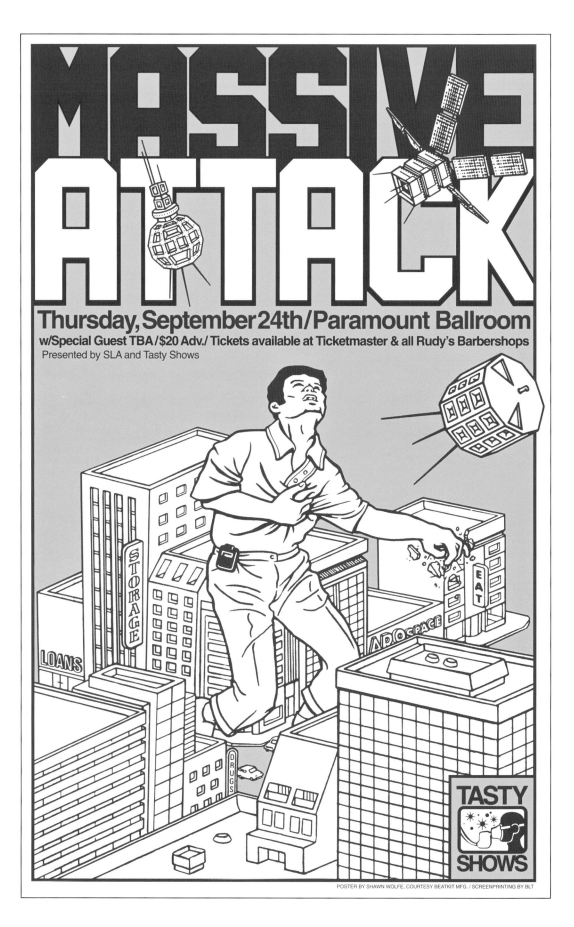

MASSIVE ATTACK

Thursday, September 24th/Paramount Ballroom

w/Special Guest TBA /$20 Adv./ Tickets available at Ticketmaster & all Rudy's Barbershops

Presented by SLA and Tasty Shows

TASTY SHOWS

POSTER BY SHAWN WOLFE, COURTESY BEATKIT MFG. / SCREENPRINTING BY BLT

TASTY SHOWS AND SWEET MOTHER RECORDINGS PROUDLY PRESENT

AN EVENING WITH DR. STRANGELOVE... OPENING NIGHT
FEATURING LIVE FROM THE U.K.
PROPELLERHEADS
w/DJ GERARD
PLUS RESIDENT DJs NASIR, LSDJ+TOPCAT
MARCH 29TH @ARO.SPACE 925 E. PIKE ST.
$10 ADVANCE / 21+OVER / TIX AVAILABLE AT RUDY'S & TICKETMASTER

this page:
Propellerheads, event poster
ARO.space, 1998

opposite:
Massive Attack, event poster
Tasty Shows, 1998

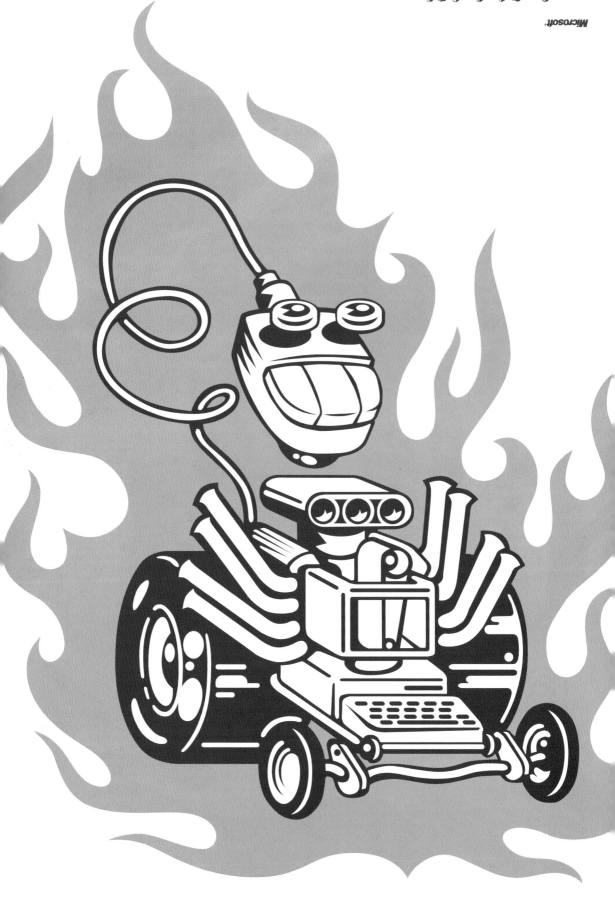

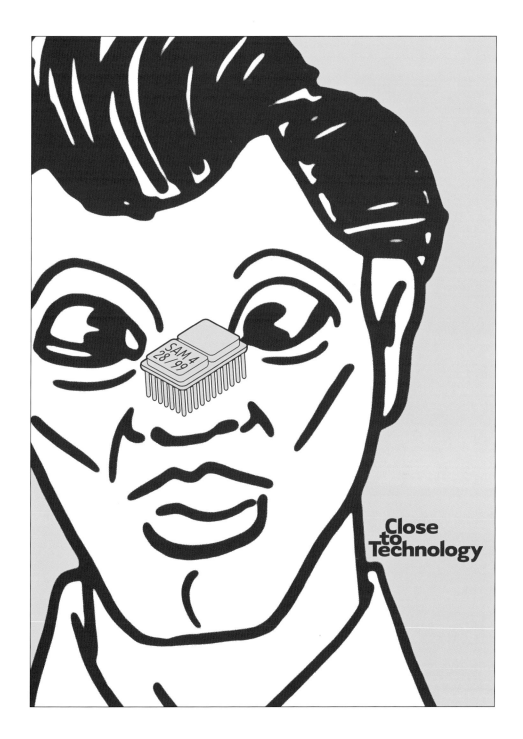

Close
to
Technology

this page:
Close To Technology, party invite
Seattle Weekly, 1999

opposite:
Mint, promotional poster
Microsoft, 1996

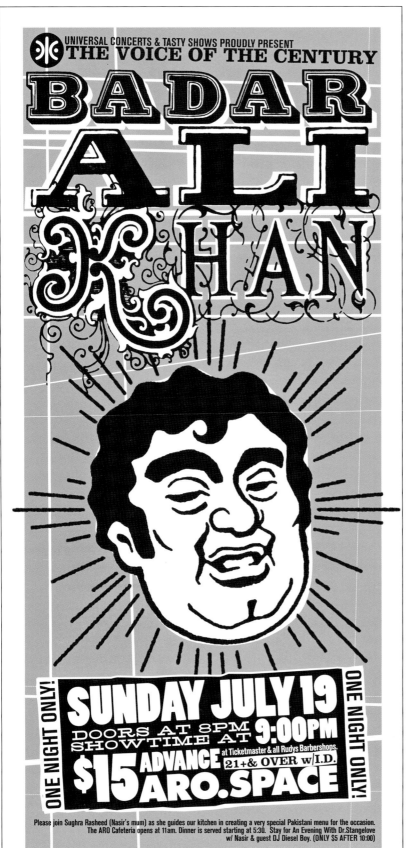

this page:
Badar Ali Khan, event poster
ARO.space, 1998

opposite:
Big Star, event poster
Tasty Shows, 1996

BIG STAR

WITH

WHITE
FLAG
MONDAY
NOV. 18TH
1996
SHOWBOX
THEATER
SEATTLE

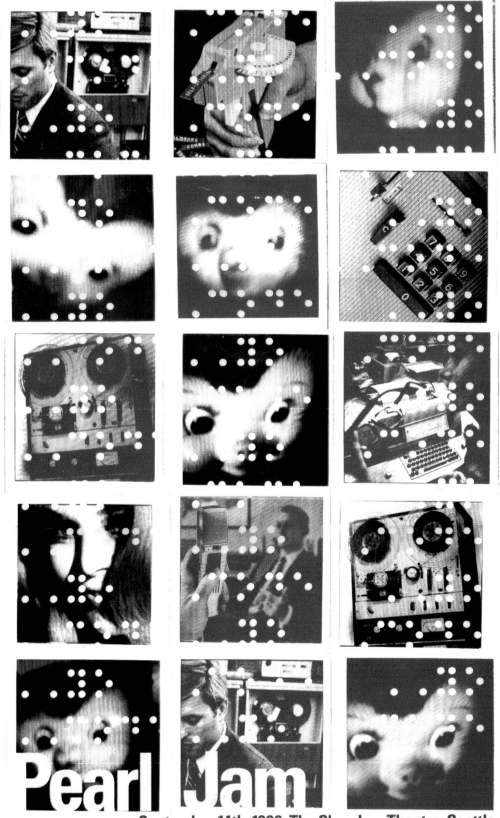

September 14th, 1996, The Showbox Theatre, Seattle
FROM THE GOOD PEOPLE AT TASTY SHOWS
poster by Shawn Wolfe

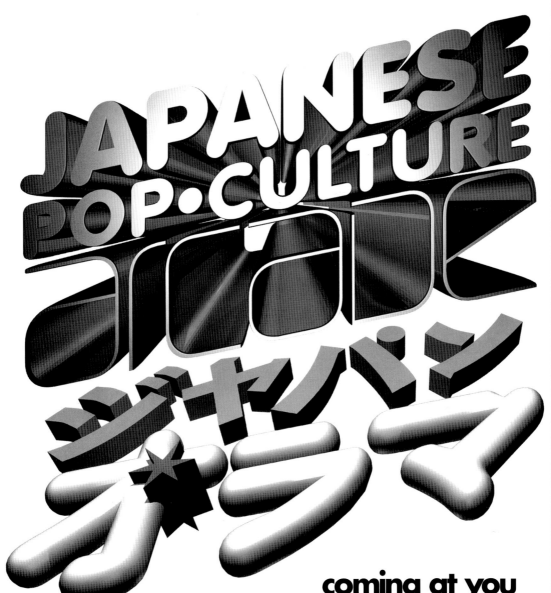

JAPANESE POP·CULTURE

ジャパン
ジオラマ

coming at you
january 26 - march 9
center on contemporary art
seattle

 coca

65 Cedar Street Seattle, WA 98121 tel. 206.728.1980

with support from PONCHO, The Japan Foundation, Kinokuniya Bookstores of America, Washington State Arts Commission, National Endowment For The Arts, Corporate Council For The Arts, Exhibitgroup Giltspur, Dark Horse Comics and Fantagraphics Books

design by **shawn wolfe**
modeling by **matthew clark**

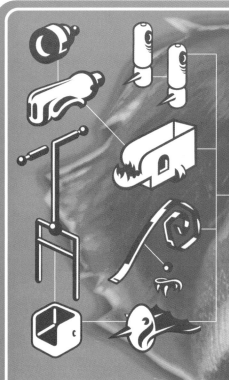
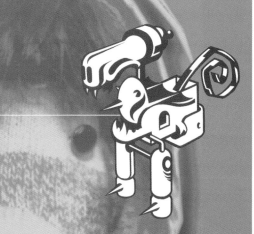

ホットアイテム

NEW CITY CON '96 PRESENTS

BEATKIT CABARET

NOVEMBER 7TH, 9:30 P.M.
NEW CITY THEATER

1634 11th AVENUE, SEATTLE, WA 98122

FEATURING A MULTI-MEDIA PRESENTATION OF
**BEATKIT: AN ADVERTISEMENT FOR
ITS OWN FUTURE USELESSNESS**

WITH LIVE PERFORMANCE BY
THE ZAIUS ART PLAYERS

AND SPECIAL GUESTS
THE PRIMATE FIVE

 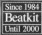

Since 1984
Beatkit
Until 2000

IN COOPERATION WITH BEATKIT WORLD SERVICING, THE ASAP GROUP & THE ZAIUS FOUNDATION FOR POST HUMAN AFFAIRS.
www.zaius.com/zaius

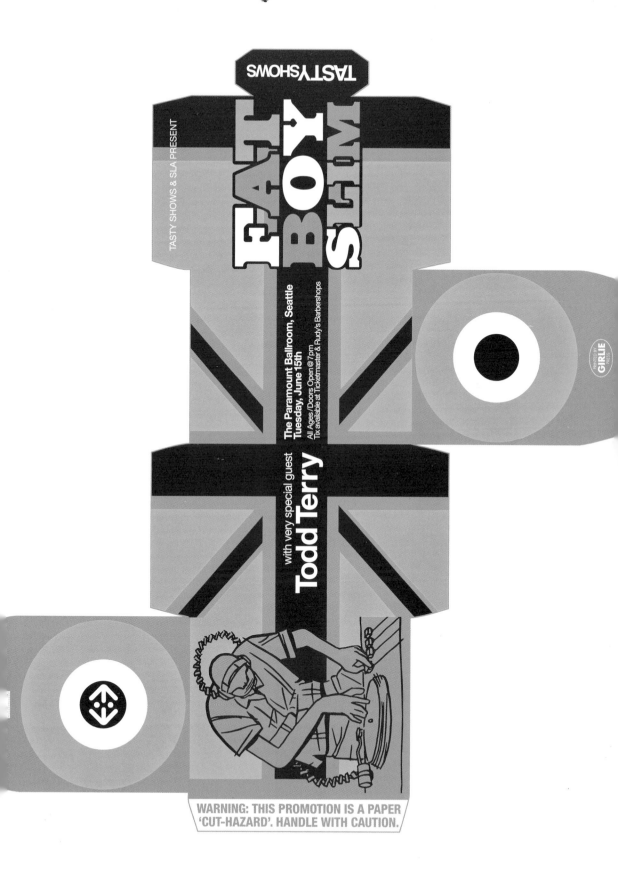

opposite:
Beatkit Cabaret, event poster
New City Theater, 1996

this page:
Fatboy Slim, die-cut event handbill
Tasty Shows, 1999

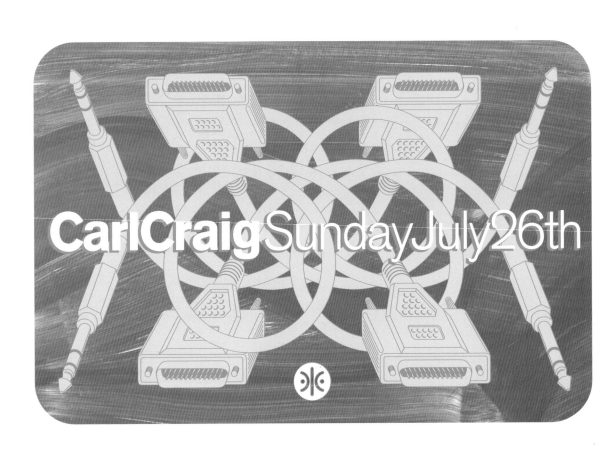

Carl Craig, event handbill
ARO.space, 1998

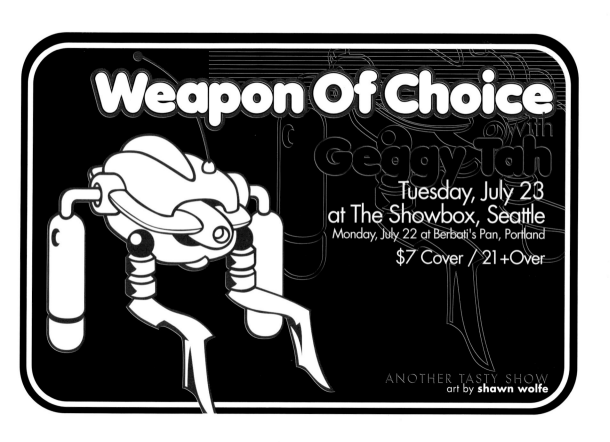

Weapon Of Choice, event handbill
Tasty Shows, 1996

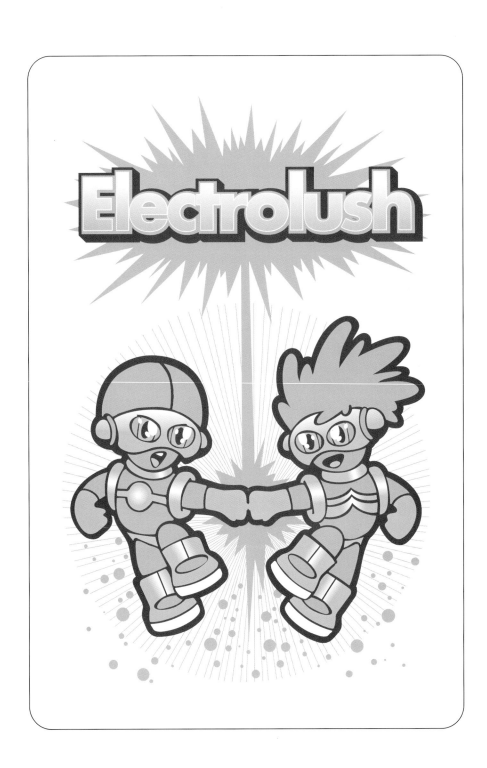

Electrolush, event handbill
Tasty Shows, 1997

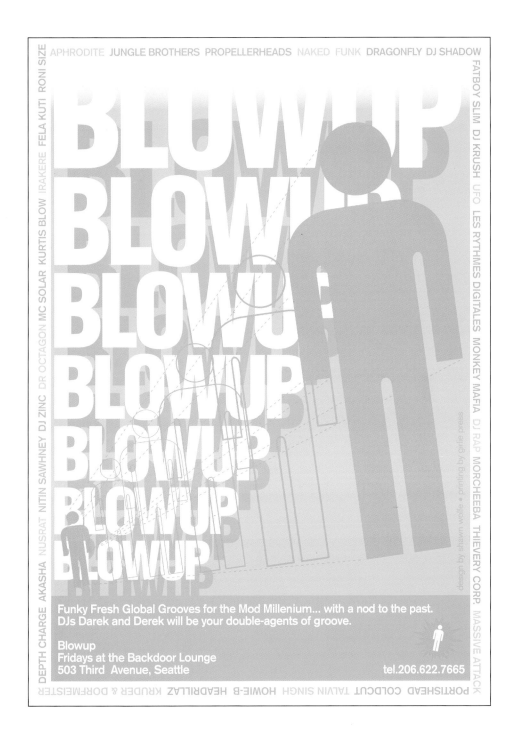

APHRODITE JUNGLE BROTHERS PROPELLERHEADS NAKED FUNK DRAGONFLY DJ SHADOW

RONI SIZE FELA KUTI IRAKERE KURTIS BLOW DR OCTAGON MC SOLAR DJ ZINC NITIN SAWHNEY NUSRAT AKASHA DEPTH CHARGE

FATBOY SLIM DJ KRUSH UFO LES RYTHMES DIGITALES MONKEY MAFIA DJ RAP MORCHEEBA THIEVERY CORP. MASSIVE ATTACK

design by shawn wolfe • printing by girlie press

BLOWUP
BLOWUP
BLOWU
BLOWUP
BLOWUP
BLOWUP
BLOWUP

Funky Fresh Global Grooves for the Mod Millenium... with a nod to the past.
DJs Darek and Derek will be your double-agents of groove.

Blowup
Fridays at the Backdoor Lounge
503 Third Avenue, Seattle

tel.206.622.7665

PORTISHEAD COLDCUT TALVIN SINGH HOWIE-B HEADRILLAZ KRUDER & DORFMEISTER

Blowup, event handbill
The Backdoor Lounge, 1998

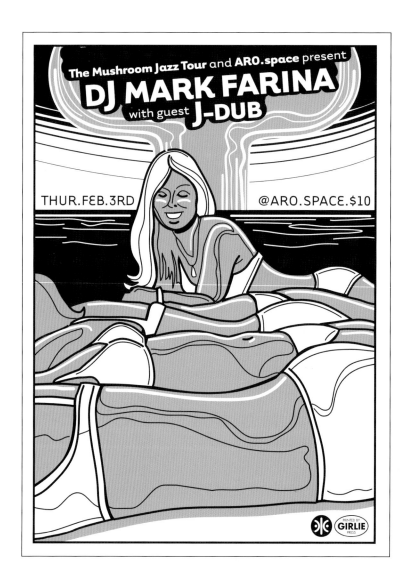

Mark Farina, event handbill
ARO.space, 2000

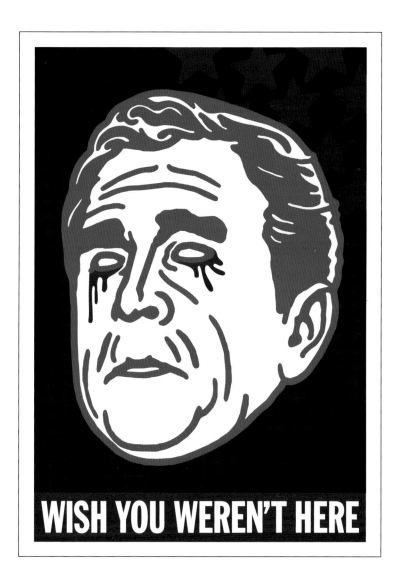

Wish You Weren't Here, postcard
Sphere magazine, 2001

Sweet Mother Recordings

ACE HOTEL

ARO

TASTYSHOWS

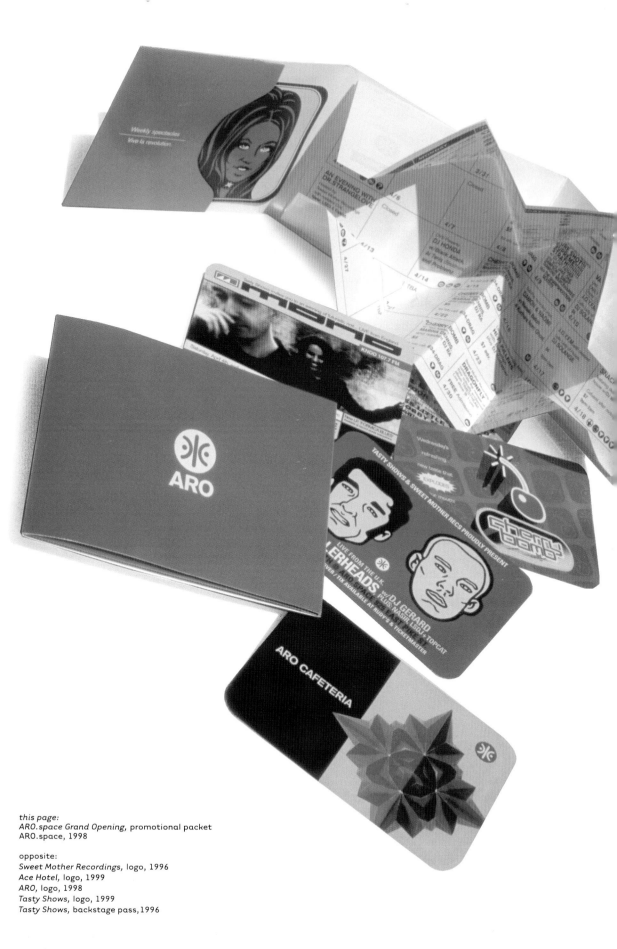

this page:
ARO.space Grand Opening, promotional packet
ARO.space, 1998

opposite:
Sweet Mother Recordings, logo, 1996
Ace Hotel, logo, 1999
ARO, logo, 1998
Tasty Shows, logo, 1999
Tasty Shows, backstage pass, 1996

NOAA West Network

LOLLAPALOOZA
FUND

post human archive

CHOICE USA

EVOLUTION ENGINE FILMS

RUDY'S
BARBERSHOPS

The Stinger, youth snowboards
K2, 1998

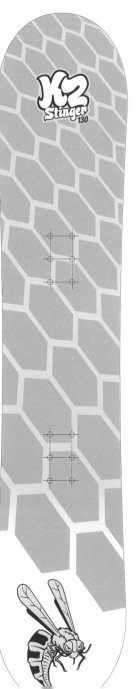

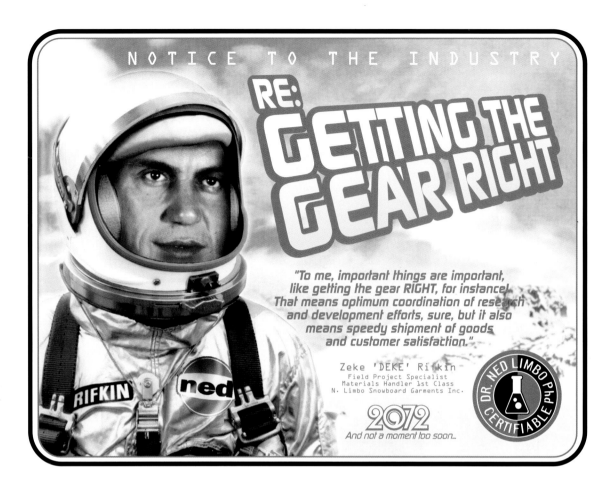
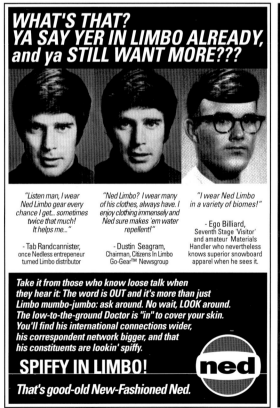
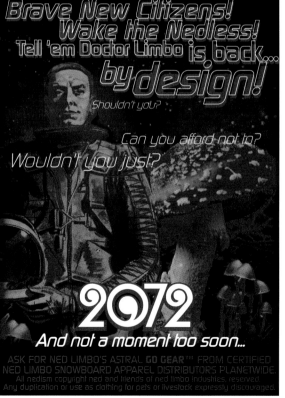

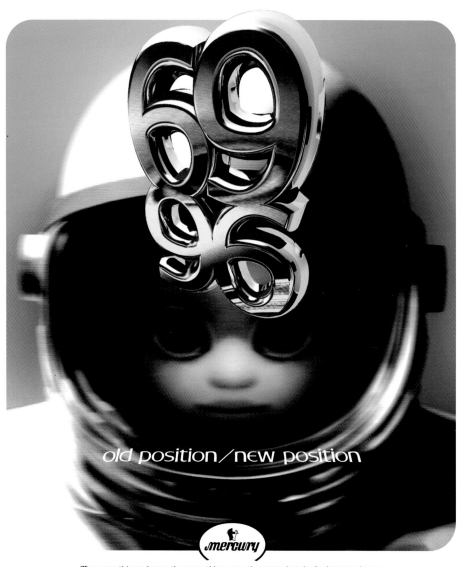

old position/new position

mercury

The more things change, the more things stay the same... but that's about to change.

©1995 PolyGram Records, Inc.

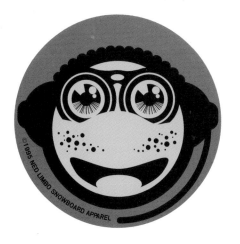

©1995 NED LIMBO SNOWBOARD APPAREL

this page:
Old Position/New Position, advertisement
appeared in 1996 MTV Video Music Awards commemorative program
Mercury Records, 1996

Ned Limbo, sticker
1995

opposite:
Ned Limbo Advertisements
copy by Darick Chamberlin
Ned Limbo Snowboard Apparel, 1996

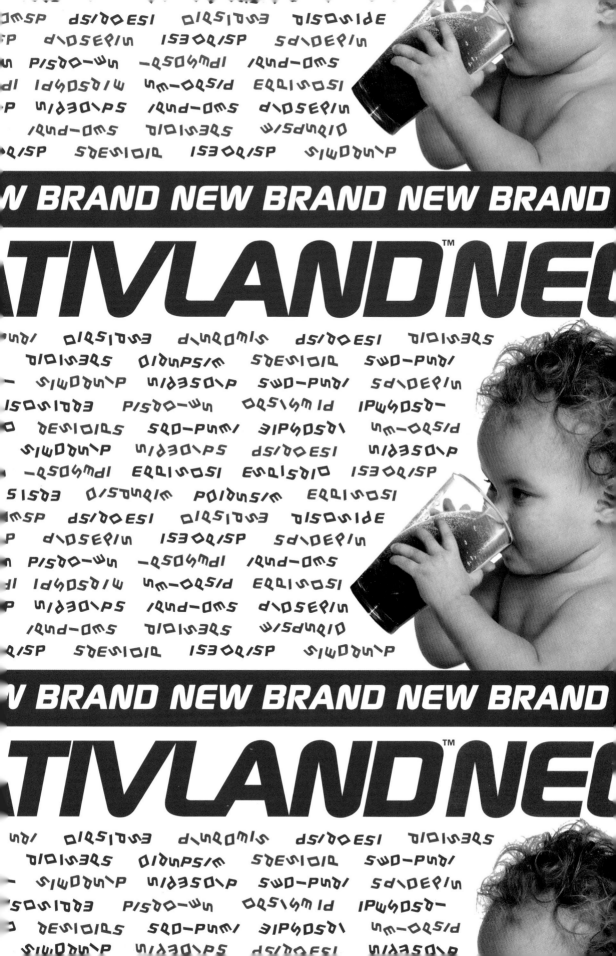

Negativland, Truth In Advertising
7" single, 1997
Eerie Materials

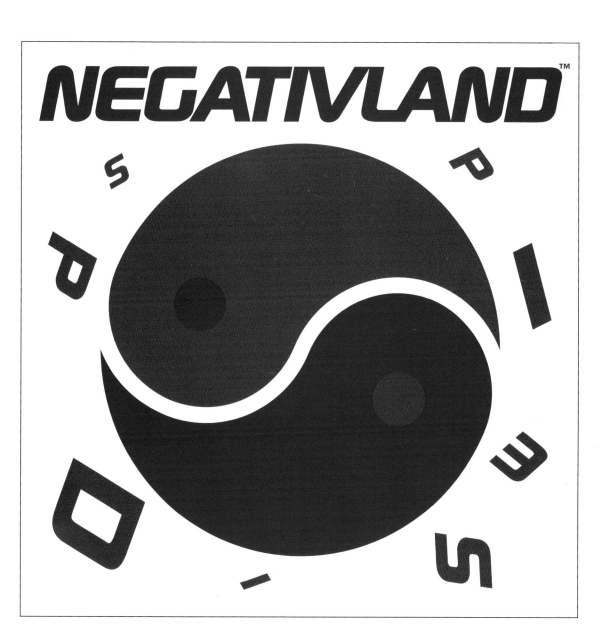

Negativland, Dispepsi
CD package, 1997
Seeland Records

Negativland, Dispepsi
CD & tray insert, 1997
Seeland Records

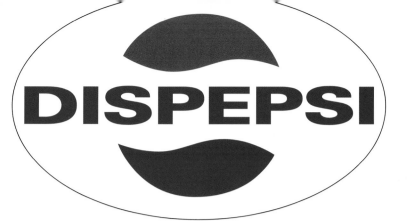

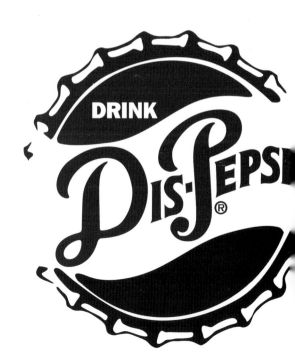

top:
Dispepsi, sticker, 1997
Seeland Records

right:
Dispepsi, t-shirt, 1997
Seeland Records

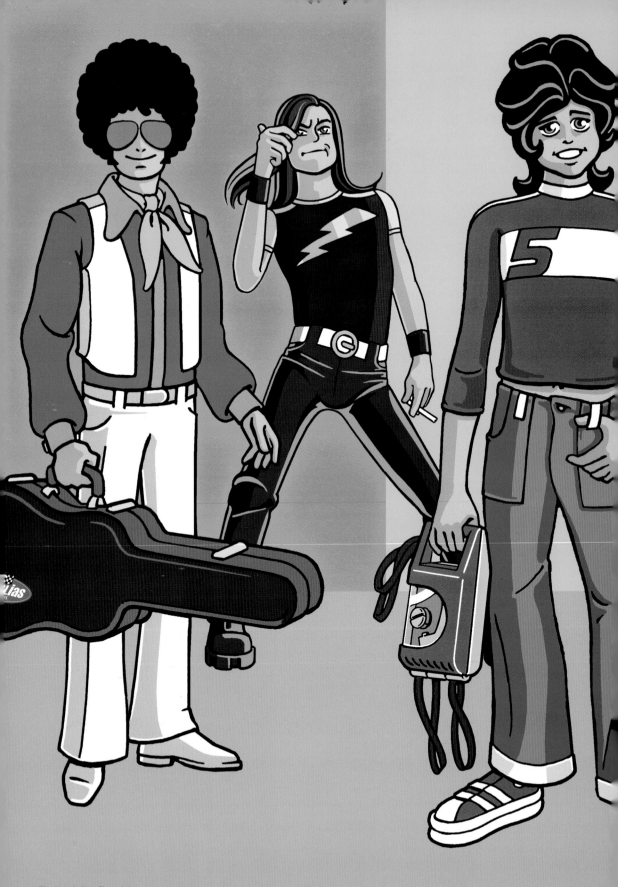

The Vandalias Chronicles
Animated Television Series, 2000
©2000 Shawn Wolfe, Dan Sarka, Pete Lockner

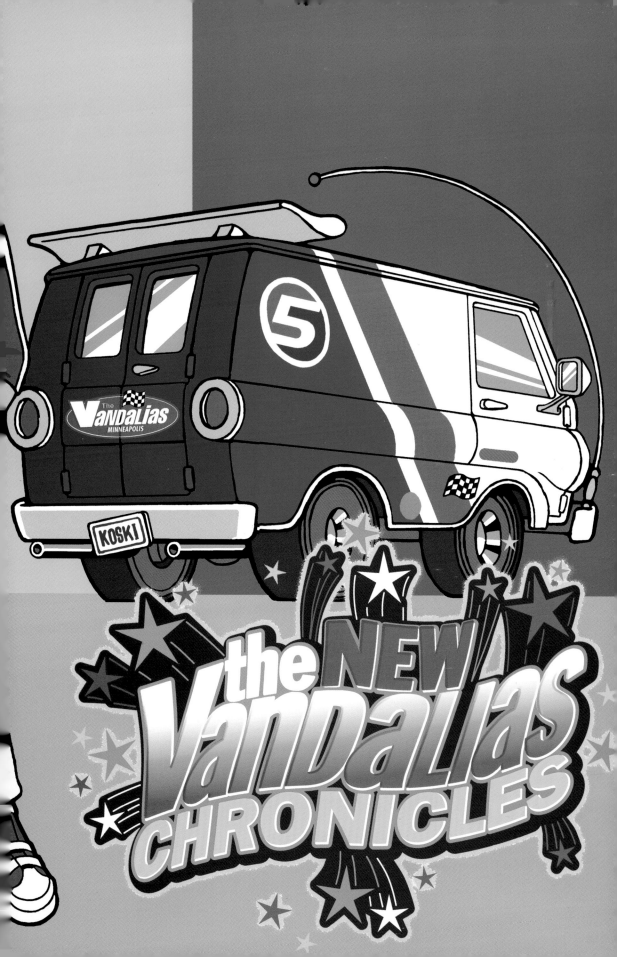

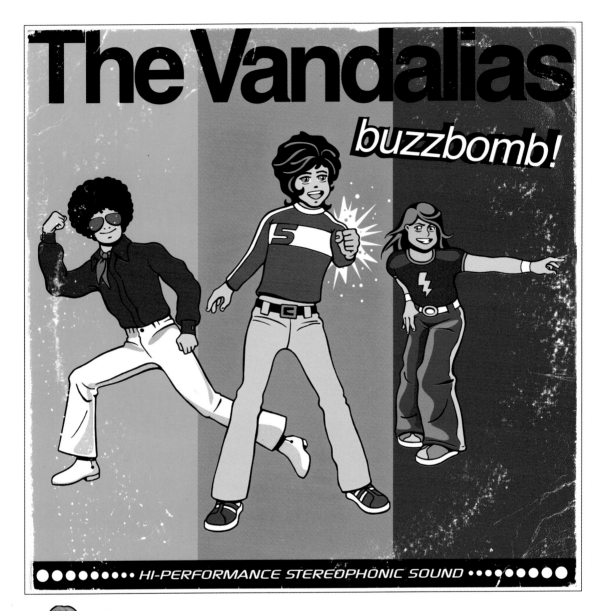

this page and opposite:
The Vandalias, buzzbomb!
CD package elements, 1998
Tenpop Works/Big Deal Recs

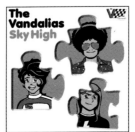

FEELPRO!

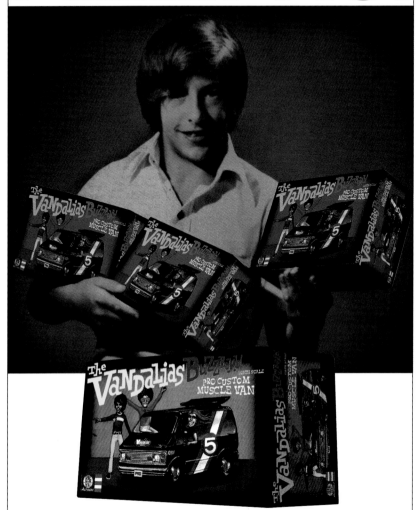

Vandalias Pro Custom Muscle Van Kits Are HERE!
And With Them, Over 700 Great Prizes!!!*

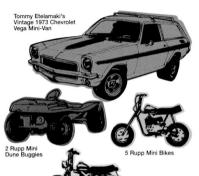

Tommy Etelamaki's
Vintage 1973 Chevrolet
Vega Mini-Van

2 Rupp Mini
Dune Buggies

5 Rupp Mini Bikes

5 Rupp
Motocross Cycles

Tenpop Works has captured
the season's hottest new
muscle van in this great
customizing kit.

Now Beatkit Special Products™
presents a special added bonus:
A chance for you to "Feel Pro!"
and win one of over 700 great
prizes in the first ever American Street Scene Idea Contest!

BEATKIT IDEA CONTEST

Simply draw your idea of an original model vehicle, a kit of your own
design... street, show, racing, rod, buggy or WILD! You may take the
grand prize, Tommy Etelamaki's customized 1973 Vega Mini-Van!
Or you may win one of two Rupp Mini Dune Buggies... or five Rupp
Motocross Cycles... or five Rupp Mini Bikes... or 50 AMF Basketballs!
Runners up may take home one of 700 other great prizes including:
25 AFX race tracks, 50 sets of Goodyear Crazy Wheels bike tires,
150 Nerf footballs, 15 Vertibird helicopters, 10 one-year subscriptions
to Hot Rod magazine, 300 Tenpop model kits or 150 Beatkit T-shirts!

Get your entry form and contest rules at any Tenpop Pit Stop
or at your nearest hobby store or department store.

it's
the real
thing!"

*Offer is not valid, no way, no how, not now, not ever.

HIGH FIDELITY
PRESENTS

THE STASH E.P.

this page:
Hi Fidelity, The Stash EP
12" single, 1996
Sweet Mother Recordings

opposite:
Feel Pro!
Vandalias contest hoax poster, 1998
model kit illustration by Scott Musgrove
Tenpop Works/Big Deal Records

Strange Voices
CD package, 1998
Sweet Mother Recordings

Faster Tiger
Little Things

FT »

Faster Tiger, Little Things
CD package, 1998
No Label

Manah
CD package, 1997
No Label

Phoenecia, Brownout
CD package, 2001
Schematic

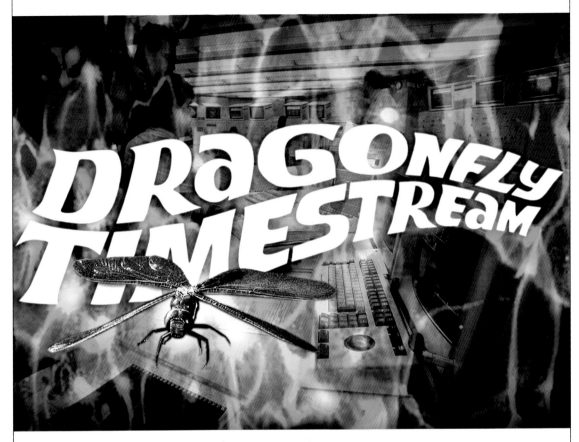

this page and opposite:
Dragonfly, Timestream
CD package, 1998
Sweet Mother Recordings

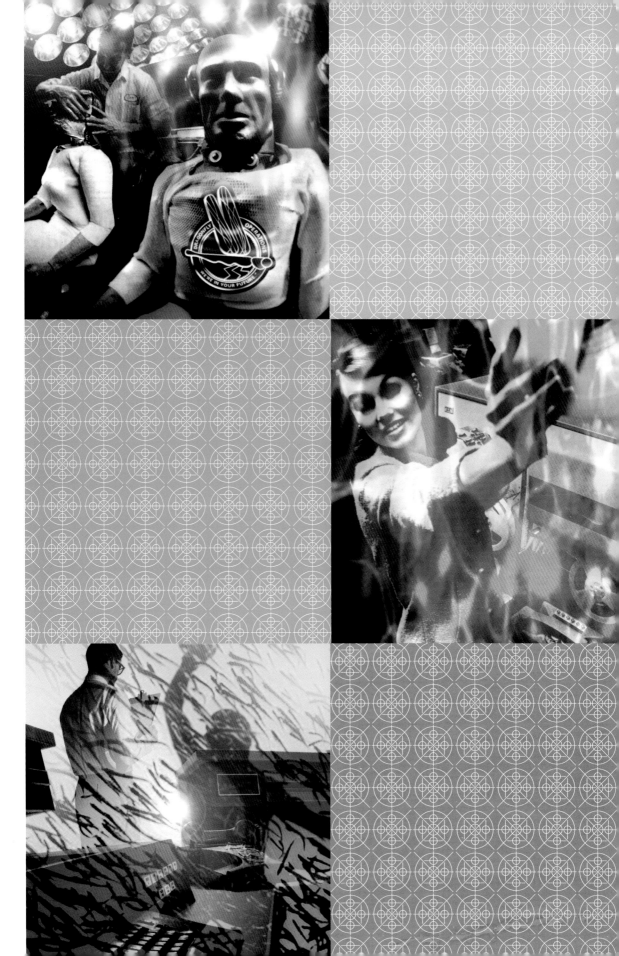

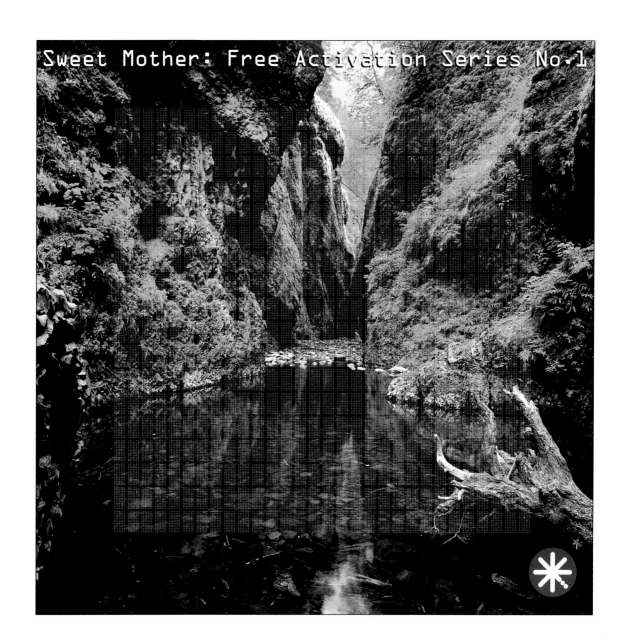

Free Activation Series No. 1
CD package, 1997
Sweet Mother Recordings/SubPop

FREE ACTIVATION SERIES VOL.2

Free Activation Series No. 2
CD package, 2000
Sweet Mother Recordings/Beams

from out of nowhere came

Dragonfly

Journeys into Ambient Hip-Hop

Dragonfly, Journeys Into Ambient Hip–Hop
12" single, 1996
Sweet Mother Recordings

Richard Peterson's Fourth Album
THE WILLIAM LOOSE SONGBOOK

Yes, I Heard Someone Who Sang Sea Sixty One
Let's Hear A William Loose Tune
Punk Rockin' Loose
Nationwide Documentary Doo-Wap
Real People Theme
Loose Spector Song
The World Tomorrow Theme
Way Up In The Mountains
See One Or None
Mount Hood Story Theme
The Metro Tunnel
See Lovin' Free
Alphabet Conspiracy
Seasick Teate
Travelog Rap

Richard Peterson, The William Loose Songbook
CD package, 1999
Pop Lama

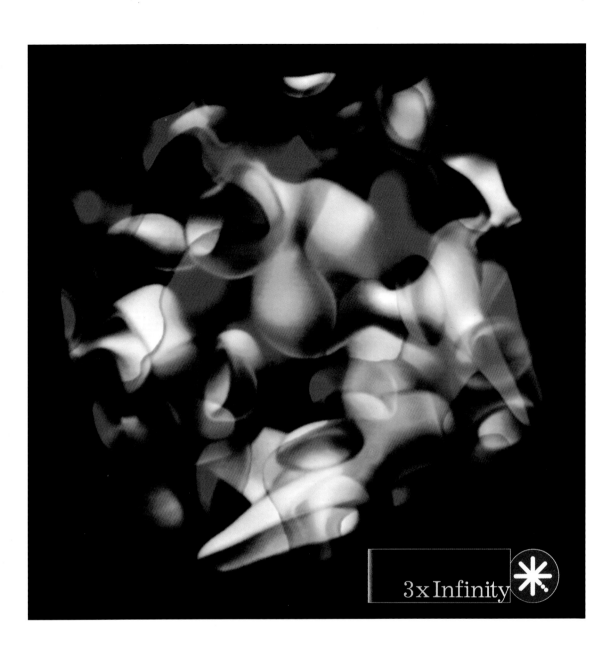

3x Infinity

this page and opposite:
3xInfinity
12" single, 1996
Sweet Mother Recordings

 # *The Sweet Mother Recording Company*

LABORING UNDER THE ILLUSION THAT THE UNIVERSE IS A GIGANTIC MECHANISM WHICH CAN BE DISMANTLED AND UNDERSTOOD

EXCLUSIVE PRESENTATION

★★★ 3x Infinity ★★★

A MAGNITUDE EQUAL TO ITSELF

Extended Play Musical Reproduction

~

*Science wrestles with the possibility
that one of two equal magnitudes
can be infinitely greather than the other.*

As the great German physicist Werner Heisenberg articulated with his now famous Uncertainty Principle, subatomic particles also have a wavelike nature, and this, among other things, means that it is sometimes very difficult to speak of particles as actually existing in any single and precise location. So we are dealing here with resonating phenomena and specifically with the idea of trajectory. Remember, *resonance* is the reenforcement of a wave (such as a sound wave) by sympathetic vibration. Whether this resonance is delivered by way of a *tone arm* or whether bursts of air are being forced through perforations in a rotating metal disc (as with a simple siren) the result is sound.

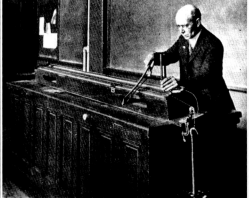

MEASURING THE EFFECT OF SURFACE CONTACT ON RESONATING NON-ENTITIES

When we speak of sympathetic vibration we also, inadvertantly, are speaking of *influence through relationship*. Whether as wave or particle the 'material atom' may be an entrance of the fourth dimension into three-dimensional space. This is known as Riemann's Law Of Surfaces. A surface, as a medium between two bodies, has no weight, but is a powerful means of transmitting vibrations from one body to another. The relationship of a surface to a solid for instance, or of a solid... to a *higher solid* is a common thing. A surface is no more than a relationship between two things. Two bodies touch. Surface is the relationship of one to the other. So if our space stands in the same relationship to higher space as does a surface to our space, then our space may be really a surface, i.e. the place of contact of two spaces of a higher order. *(4th Dimension = 3rd Dimension + Time.)*

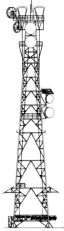

"The mystery of infinity is the greatest of all mysteries. It tells us that all the galaxies - the whole visible universe - have no dimensions as compared with infinity; that they are equal to a point, a mathematical point which has no extension whatever, and that, at the same time, points which are not measurable for us may have a different extension and different dimensions. In 'positivist' thinking we make efforts to FORGET ABOUT THIS, NOT TO THINK ABOUT IT. At some future time positivism will be defined as a system which enables one not to think about real things and to limit oneself strictly to the domain of the unreal and the illusory." -*P. D. Ouspensky*

BEATS: *A succession of loud sounds separated by intervals of relative silence.*

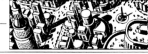

THE TWO LIGHT CURVES REPRESENT SETS OF SOUND WAVES HAVING A VIBRATION RATIO OF FIVE TO EIGHT. THE HEAVY CURVE REPRESENTS THE RESULTANT SOUND. FOUR POINTS OF REENFORCEMENT AND THREE OF INTERFERENCE ARE SHOWN.

TRACK LISTING: VERIFIED

1. Wonderland *(Vocal Mix)*
Ⓐ 2. Wonderland *(Bad Trip Mix)*
3. Wonderland *(Loon-E Version)*
4. Wonderland *(Sabotage Mix)*
Ⓑ 5. Wonderland *(Instrumental)*
6. Wonderland *(Instrumental)*

WHILE THE LOWEST SOUND THAT THE HUMAN EAR CAN DETECT IS MADE UP OF 16 VIBRATIONS PER SECOND, THE HIGHEST DETECTABLE VIBRATION FREQUENCY IS 40,000.

All tracks written and produced by
Nasir Rasheed, Christopher Anderson and Rob Stewart.
Track #1 vocals written and sung by Nikkol Kollars
Track #3 remixed by Dragonfly *(C. Anderson and R. Stewart)*
Track #3 rap written and performed by Loonatic *(from Lyrical Influence)*
Track #4 remixed by L. McKeehan *and* A. Randle
All tracks except Track #4 recorded and mixed at
Michael Lord Studio, Seattle, WA. • Engineer Michael Lord
Track #4 mixed and remixed at Mo Funk *studios, Vancouver BC.*
Sleeve concept & deployment by Shawn Wolfe

Sweet Mother Recordings
©1996 Sweet Mother Publishing, Inc. (BMI)
1506 11th Ave. Seattle, WA 98122
www.neverstop.com

SM005
ALL RIGHTS RESERVED

OUR PRICE

6 14974 00501 7

CERTIFIED

commercial art and.

having beers in a small seattle bar is my most vivid memory of shawn. not
for the beer, but the conversation. it was our first in-person meeting.
i remember
thinking he looked his part, but not overly so. just kinda seattle post
grunge... he voiced
genuine concern and interest in hearing me tell of my nephew's recent
accident that had left
him a paraplegic at 22 years old. shawn always asked about him in our
subsequent phone
conversations. it meant a lot to me.
shawn's a sincere, down to earth kind of guy in a strange ohio kind of way.
and he has a very nice wife who he's really good friends with.
in 1994 when i rescued shawn, he was busy seducing the masses into buying
things they didn't
need at a small seattle advertising agency. my first intern at ray gun,
actually my first
employee, amy lam, suggested i see his work. he had sent me stuff earlier
but it hadn't
registered. trusting amy, i began feeding shawn a few pages per issue.
usually articles i
didn't want to mess with, like organizing all those record reviews...or an
article i had no
interest in. or when we couldn't fill an ad space. shawn turned them all
into mini-
masterpieces.
i never knew what i would get from him, and i was never disappointed. and
always surprised.
there's an intelligent absurdity to his work. i think that's why i was so
drawn to it. and
it never looked like what anyone else was doing. especially me. shawn's
work was totally
out of step with what all us 'cool' designers were doing at the time. which
of course, was
part of its brilliance. and i felt like a proud father when one of the
design magazines
recognized his work with a 10-page article-some 5 years after his first ray
gun spread.....
no question some of the best pages in ray gun were shawn's. i should have
given him more........

p.s . don't pass this book on to any friends. get them to buy their own.

david carson, nyc, 1999

rg:0.30rec/////

MACHINES OF INSTANT UTILITY:
NOW WITH **30% MORE** END OF PRINT!

C'est peut-être du vide comme
est le vide, mais si grand que le
Bien et le Mal ensemble ne le
remplissent pas. O! Que j'aille
dans les lieux inhabités, Loin
des annonces, et que j'y
laisse rire et hurler.

ASAP
Entropy

USA

J'interroge le ciel.

Reviews edited by Nina Malkin
WITH AUSPICIOUS CELEBRITY GUEST REVIEWERS

NOTICE TO CUSTOMERS
No price for any article listed herein exceeds the ceiling price for that article as determined under applicable maximum price regulation issued by the Office of Price Administration and the Limits Unlimited Association. As required by that office we will, upon request, furnish you with a statement of our maximum prices on any commodity listed about which you inquire. *Raygun Manufacturing, Inc.*

Raygun Reviews
splash page, 1996
Raygun

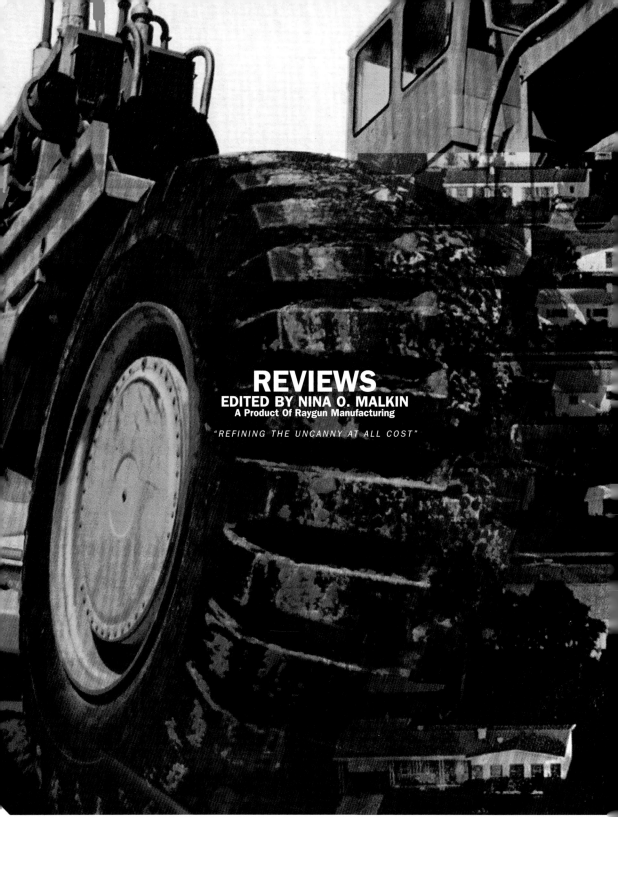

REVIEWS
EDITED BY NINA O. MALKIN
A Product Of Raygun Manufacturing

"REFINING THE UNCANNY AT ALL COST"

Raygun Reviews
splash page, 1995
Raygun

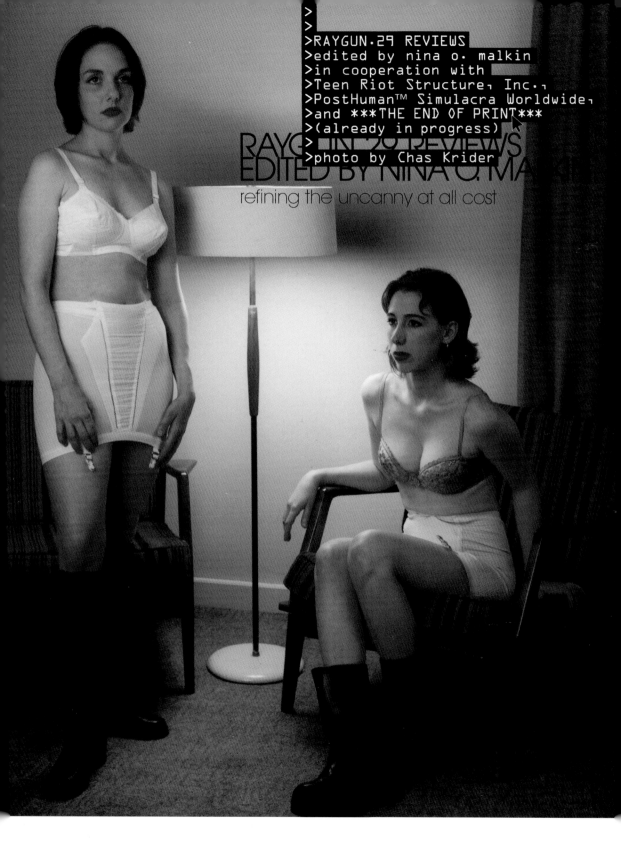

>
>
>RAYGUN·29 REVIEWS
>edited by nina o. malkin
>in cooperation with
>Teen Riot Structure, Inc.,
>PostHuman™ Simulacra Worldwide,
>and ***THE END OF PRINT***
>(already in progress)
>photo by Chas Krider

RAYG IN 29 REVIEWS
EDITED BY NINA O. MALKI
refining the uncanny at all cost

CAN YOU KEEP A SECRET?

The Raygun corps of engineers is busy around the clock with the manufacture of fourth dimensional *'products'* that are guaranteed to reverse entropy and effectively up-end the second law of thermodynamics in our time!

BUY TO LAST

RAYGUN MANUFACTURING
"Refining The Uncanny At All Cost"

this page:
Can You Keep A Secret?
mock advertisement, 1995
Raygun

opposite:
Don't Be Stupid!
mock advertisement, 1995
Raygun

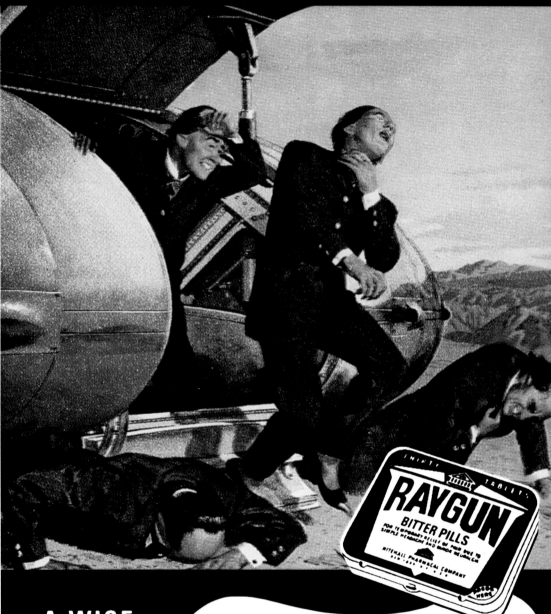

Raygun Reviews
splash page, 1994
Raygun

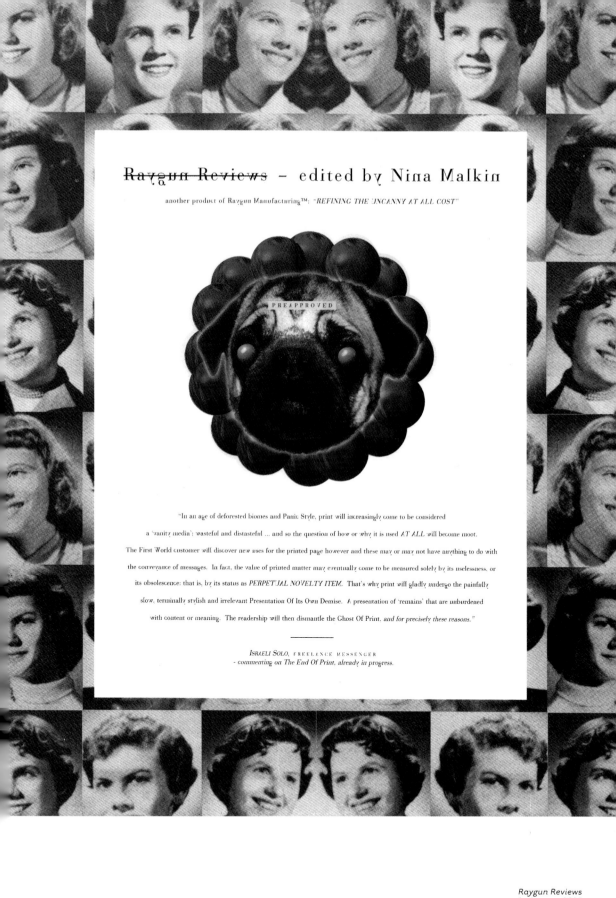

~~Raygun Reviews~~ – edited by Nina Malkin

another product of Raygun Manufacturing™: "REFINING THE UNCANNY AT ALL COST"

"In an age of deforested biomes and Panic Style, print will increasingly come to be considered a 'vanity media': wasteful and distasteful ... and so the question of how or why it is used AT ALL will become moot. The First World customer will discover new uses for the printed page however and these may or may not have anything to do with the conveyance of messages. In fact, the value of printed matter may eventually come to be measured solely by its uselessness, or its obsolescence: that is, by its status as PERPETUAL NOVELTY ITEM. That's why print will gladly undergo the painfully slow, terminally stylish and irrelevant Presentation Of Its Own Demise. A presentation of 'remains' that are unburdened with content or meaning. The readership will then dismantle the Ghost Of Print, and for precisely these reasons."

ISRAELI SOLO, FREELANCE MESSENGER
- commenting on The End Of Print, already in progress.

Raygun Reviews
splash page, 1995
Raygun

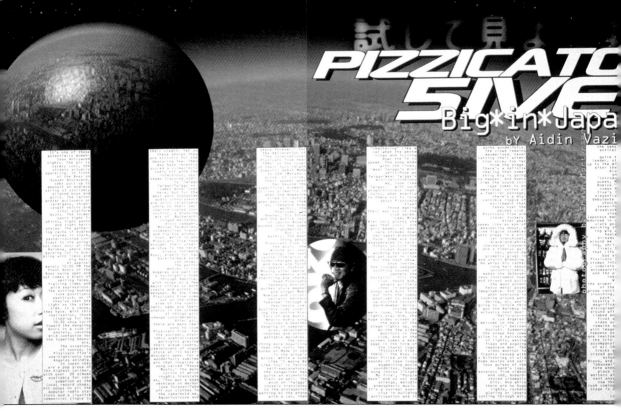

PIZZICATO 5IVE
Big*in*Japan
bY Aidin Vazi

Pizzicato Five (above)
interview, 1995
Raygun

Raygun Reviews (below)
splash page background illustration,1995
Raygun

Jerry Lee Lewis (below)
interview, 1996
Raygun

Raygun Reviews (above)
splash page, 1996
Raygun

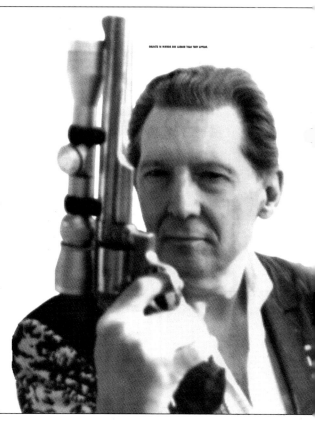

JERRY LEE
LEWIS
INTERVIEW
BY HENRY ROLLINS

The Lewis Ranch sits on a road in Nesbit, Mississippi. Huge gates with a piano across the front guard the driveway. The house sits overlooking a lake and several acres of beautiful land. About a dozen dogs get up and wander over to the car as I get out to interview Jerry Lee Lewis, whose new album *Young Blood* is great, straight-up rock 'n' roll record. I had taken a tour of the house the night before and had all of my questions as ready as I could. I wondered if I could hold my own with Jerry. I could not have been a better time. He was friendly and humble as if he didn't know all the great music he had made for so many years. I had a blast. A few hours later, I was sitting in a hotel room in New York, blown away at the great day I had.

Henry: I want to ask you about your first recordings back in the Sun days and about the time that you went in and recorded "Crazy Arms"

with Jack Clement. It ended up being your first single.
Jerry: Me and my dad drove up. I was to meet Mr. Phillips, and Jack Clement was standing there and he said, "Well, he's not here, he's gone on vacation. Can I help you?" I said, "Yeah, I want to audition, I play piano and I sing." He said, "Well, I never have any time." And I said, "Well, you going to have to take time

for this." I drove a long ways and we didn't have a whole lot of money back then, so kinda in a casual way, he said, "Well, I got about three or four minutes — tell me what you are going to do." So I started playing some songs. "That's pretty good," he said, "but can you play a guitar?" [Laughing] Yeah, I can play a guitar, but I'm a piano player."
That's how we got into it and to make a long story short, I kinda pushed him into recording "Crazy Arms." The only thing he mentioned about "Crazy Arms" was that the song had been done by different major artists already. I was, "Yeah, but let me do it." I done it my way, and he played it for Mr. Phillips two weeks later, and he released the

Raygun Reviews
background illustrations, 1994
Raygun

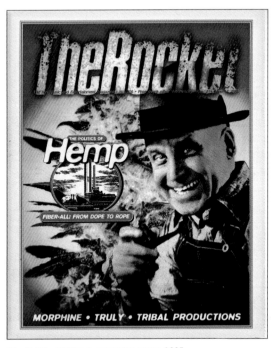

The Politics Of Hemp, magazine cover, 1995
art director: Stuart Williams
The Rocket

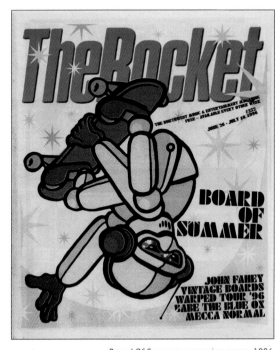

Board Of Summer, magazine cover, 1996
art director: Stuart Williams
The Rocket

opposite:
Hero Pile-Up, magazine cover, 1994
art director: Jason Lutes
The Stranger

CAUTION: CONTAINS DILDO BABES

the Stranger

Free Weekly 10 through 16 January, 1995 Vol. 4, Number 15

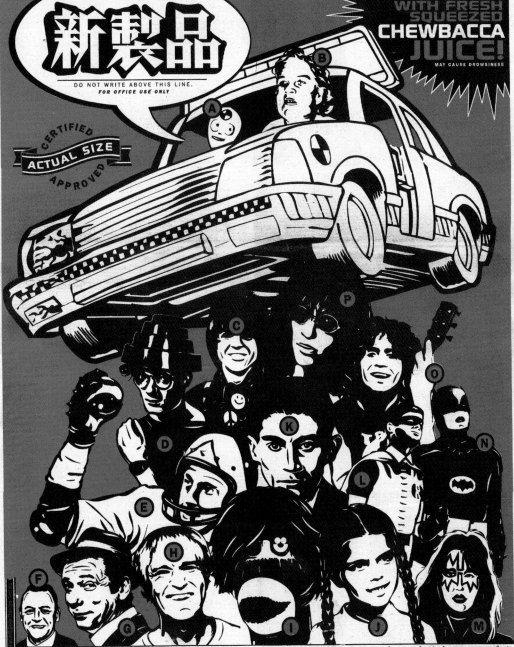

新製品

DO NOT WRITE ABOVE THIS LINE.
FOR OFFICE USE ONLY

CERTIFIED ACTUAL SIZE APPROVED

WITH FRESH SQUEEZED CHEWBACCA JUICE!

MAY CAUSE DROWSINESS

A.)Crash Test Moderator B.)The Joe Kafka Lady C.)Bay City Twerp D.)Dying Under Daddy's Cap E.)Yves Montana With Bleach F.)Johnathan G.)Kurt Schwitters Life H.)Timothy Leary's Underpants I.)Sock Monkey J.)Original Formula Wednesday K.)Complete Office System RemoverInstaller O.)Compensation Institutions Inc. L.)Sissy Boy M.)Ace On Your Mom N.)Adam West For Men O.)Mater Bolan's Head In a Mason Jar P.)Riboflavin

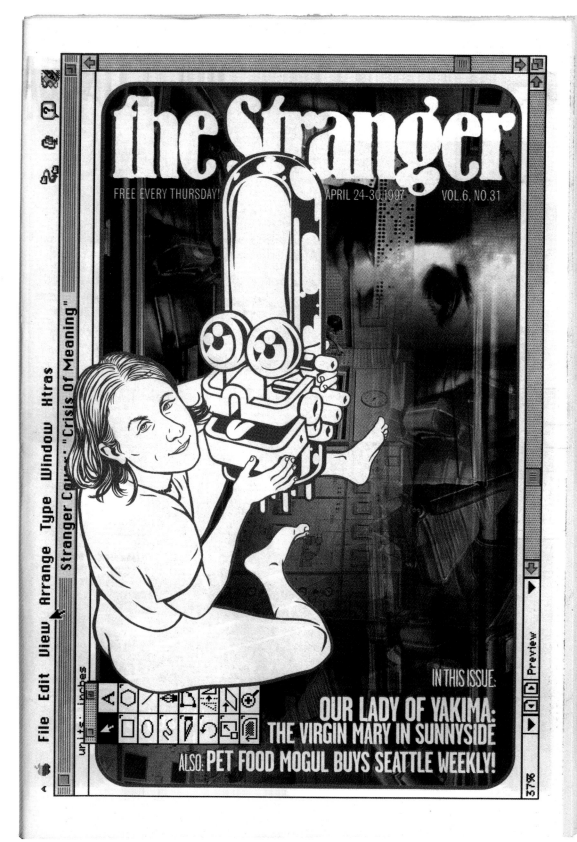

Crisis Of Meaning, magazine cover, 1997
illustration by Ellen Forney and Shawn Wolfe
art director: Dale Yarger
The Stranger

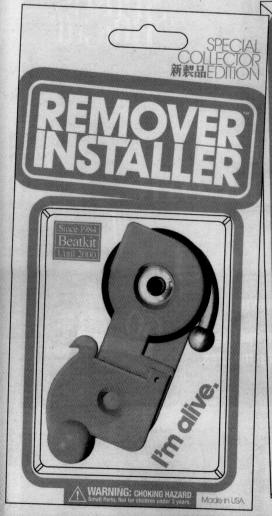

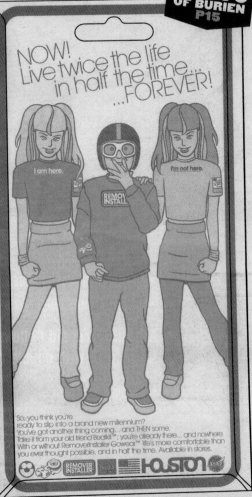

Music Mart

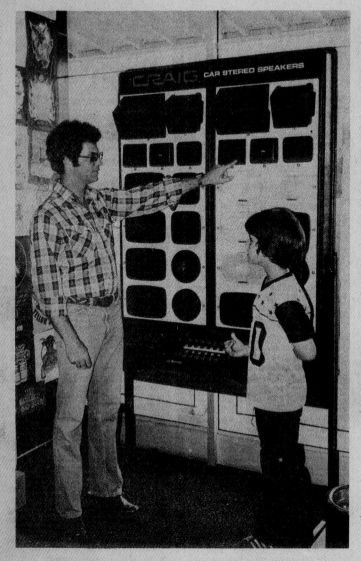

Dave Wolfe, owner of the Music Mart, points out special features of some of the Craig car stereo speakers on sale in his store on Coshocton Ave, to his nine-year-old son, Mark. The store also stocks over 600 titles in top rock, country and disco recordings.

Put a song in your heart — visit the Music Mart!

Dave Wolfe, owner of the store located on Coshocton Ave., invites persons of all ages to stop by to see and hear the latest in music hits or to view the new line of T shirts and jeans the Music Mart now offers customers.

The store stocks the top 200 rock albums and tapes on the charts — all at discount prices — and carries a complete selection over 600 titles in top rock, country and disco 45 rpm records. "We are able to fill requests for those "oldies but goodies" too," says Wolfe.

With the recent popularity of disco music, the Music Mart now offers the most popular disco hits available in 12-inch long playing 45's for six to eight minutes of listening and dancing enjoyment.

The owner will gladly order any record or tape he does not have in stock.

The Music Mart now carries a complete line of T shirts in all sizes for adults and children, along with an assortment of men's and women's undershorts. The store has the equipment that takes only one minute to apply transfers and letters. "There is no waiting," explains Wolfe.

The selection of transfers includes 150 album and cover prints, movie prints, slogans, superstars and rock groups. Preprinted T shirts are also available at the store, or customers may bring in their own shirts for transfers.

Four types of lettering are available for transfer, including two-inch flock block, rainbow glitter, irridescent and two sizes of black.

The Music Mart now carries a complete line of jeans — all at discount prices — with womens sizes 5-13 and men's 28-38. Skirts, vests and jackets are available to complement the jeans or to wear individually. The store also offers customers a fine selection of jewelry for daytime and evening wear.

"The store offers customers the most complete up-to-date selection of eight-track, cassette blank tapes, and car stereo equipment in Knox County," the owner said.

"I feel Panasonic and Craig are the best a person can buy in car stereo components," Wolfe pointed out.

A new display at the Music Mart includes Craig car stereo speakers with models in a wide range of prices, different sizes, power ratings and wattage variances.

(This article is an advertisement for one of the 26 businesses which appears

All s
stereos
year.
The st
of Hand
use.

Mount Vernon, Ohio, 1978

My Life At The Point Of Sale

It is estimated that the average American is exposed to over 1,500 ads each day. We're all subjected to roughly the same overwhelming powers of persuasion. We do our best to process or tune out the barrage of advertising messages. We recognize or ignore all the brand names that assert and reassert themselves from virtually every surface we encounter, including our own bodies. We mentally escape into idealistic lifestyle images that make no true or false claims but are nevertheless devised solely with the intent to make us uncomfortable inside our own skin. The constant assault on our senses is so pervasive and invasive, we have grown accustomed to it, as a totality. It really has become the (polluted) air that we breath. With this in mind, I've convinced myself that my work amounts to more than just a personal grudge. I have a worthwhile cause, something that we are all caught up in. For those who still can't see the forest of ads for the trees felled to print them on, I'm their friendly park ranger. So I'd like to believe.

I never thought there was anything too unusual about my childhood. Brought up in a middle class home in the small town of Mount Vernon, Ohio, I was more or less well-adjusted, happy, cared for, loved. The intervening years have done nothing to alter that perception. But as I continue to wrestle with the unruly advertising beast I have to ask myself why or how it came to be that this cultural *battle royale* should continue to be my chronic obsession as an artist and a person.

Today I look back over my young life and realize it was probably inevitable that I should go down this road. During my childhood I spent countless weekends with my grandparents who owned their own mom & pop store. This was a wonderful part of my so-called normal childhood and to this day I cherish the memory of times spent loafing around Dicken's Grocery, stuffing my face with Marathon bars and Mountain Dew. I am told that as a tyke I took my naps beneath their cash register, laying atop a stack of brown paper bags under the counter while the cash drawer banged open and shut with every transaction. Throughout my teenage years in the 1970s my parents owned a groovy little record store called Music Mart where I spent a lot of time helping out, hanging out and poring over the Billboard Hot 100. From there I drifted through a series of retail and fast food jobs that sustained me during my college years before eventually moving on to my first "real job" with an outfit called, aptly enough, Retail Planning Associates. My first art director didn't know, nor would he have cared, but by then I had literally lived my whole life *at the point of sale*. I spent the next seven years working in and around advertising, *inside the beast*, gleaning firsthand knowledge of the enemy. The money was good and I had student loans to pay back, but other than that it was a miserable time. These were lost years that I later wished I could get back.

Wanting to see to it that 'everything happens for a reason'—down to the naps we take underneath grandma's cash register—about ten years ago I resolved to put my retail/advertising/branding experiences to some use. So Beatkit, which had previously existed as a fanzine whose purpose was to provide my art school friends and me with an alternative means of expression, was renewed—reincarnated, actually—as the world's first ever *anti-brand*. A 'brand without a product', the new improved Beatkit™ would be a shining example of what was sick and wrong in a culture gone mad with consumerism. I spent the remainder of the century using it as my own personal fun house mirror to satirize and expose what I considered the dark nature of consumerism, specifically *the brand mentality*. Real brands, emblematic of mass-produced goods, exist only to perpetuate their own existence. The strongest most enduring brands have managed to outlive many generations of consumers. A badge of identity for consumers who are themselves mass-produced to want those goods, brands are always there to help us piece together who we are. So the thinking goes. Thus are we all encouraged to participate in a continuous act of consumption (and disposal) that serves ultimately to escalate all of the most fundamental crises of contemporary life; the using up of natural resources, ecological ruin, cultural gentrification, emotional detachment, cynicism, alienation, ambivalence and so forth. As an anti-brand Beatkit™ has hopefully managed to lay bare some of these truths, or at least disrupt some of these cycles for a moment or two. And now, as its final act of common decency, Beatkit™ must die.

Shawn Wolfe, Seattle, 2000

Beatkit lay dead for three days

Alleged Ad Campaign, Fine Example Of Constructional Linguistics Wed To Ritual Death

BY ROMAINE SIVALINGA
Copy Planet staff reporter

(12:31/99/AM edition)

SEATTLE — Typographic 7th seal Beatkit, heavy into drugs and afflicted with what insiders are calling 'serious subscriber access problems', shot itself in the headline in the late afternoon or evening of December 29, mere days before its masthead completed itself and history prepared for a total or near-total erasure, insiders report.

The time of death, released yesterday by insiders at the Esalen Institute, punctuates eerily the final months of the plucky, millennially-obsessed anti-brand, but answers fewer questions than it raises, insiders say.

Meanwhile, in another twist to the drama surrounding Beatkit's auto-amputational design emphasis (termed by one insider as 'predesigned obsolescence'), police in Columbus, Ohio, reported yesterday that Beatkit's previous memetic avatar, Pure Love, was arrested on drug charges December 30 - the day before Beatkit's body copy was discovered.

Police and fire officials and even a game warden were called to the sprawling, luxurious Wexner Center for the Arts early that morning and all worked in tandem to treat Love for a suspected Lexan™ overdose and to urge her not to change her name back to Pain, presumably for "the last and final time," insiders say.

She was charged with possession of

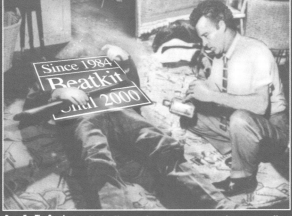

Down For The Count: *Beatkit finally sees the writing on its own late great wall. Two thousand unopened boxes of engraved invitations found at the scene read, "History failed. Future useless. '90s fried-thru. Thank You. The Management."*

a controlled semi-transparent substance, a felony in the Buckeye state, as well as with misdemeanor possession of both Bernie Taupin solo albums, police said. Love said last night that she was "Pure Love" and that she loved not only the night life, but "the love that gives The Love a good day's lovin'," as well. Love told reporters that she had only been attempting a "dynamic translogical unitary experience" and that she was therefore unable to comment further

on the charges or on the anti-brand using any presently employed terrestrial grammar or system of grammars.

The temporally unlocatable cataract point in the space/time fabric known to some insiders as *The Eschaton* was also unavailable at presstime for comment.

Beatkit's apparently gestural suicide was not discovered until Friday morning, when a wily bicycle courier spotted the so-called "Revenge of the Fragment" laying (or rather, 'lying')

face up, wasted, suffering from a severely lessened resolution, and completely reversed-out of a strip (called a 'track') of online advertising that was being test-marketed recently in so-called 'cyberspace', all in a compressed, niche-market effort to stoke a slagging global economy in the face of recent trade slumps and the ongoing, bitterly waged, so-called 'Fresh Water War'.

The level of 'poorly concealed hostility' in Beatkit's *raison d'etre* was sufficient to have caused the intoxicating and fatal enthusiasm necessary at first to precipitate the kinds of gestures Beatkit was eventually ultimately capable of by then , an inside source revealed.

In a candid interview which took place on a couch and which was conducted for rebroadcast via cable access television yesterday, Love acknowledged her own problem with drugs and said she wanted to send a message to fans that drugs in and of themselves don't solve anything.

"Drugs should be taken only with equal parts sex and Thai food for the right mix," she said, hours before SWAT teams busted into her cozy Columbus apartment for the nab. "The availability of drugs is a problem, and this distracts people from noticing how out-of-kilter the whole thing is, you know what I mean? That's, like, the root cause of sh*t like this, things being all f*cked up to begin with. Not that other stuff."

see *Poison Foods In The Can,* page A4

Love: Dead In The Bed; continued from page A1

Copy Planet reported yesterday that Love had become increasingly frustrated by the inability of Kansas City police to effectively deal with the 'grey magic' question of late, insiders postulate.

Love has been under enormous stress from all the acceleration and media poisoning that accompanies Information Sickness in its final, terminal formats.

"I thought we'd learned something from Rome, or at least from Trinity by now", Love sighed Sunday. "Beatkit had a rough idea of what Einstein was talking about here," Love added with a tone called cryptic bt some eyewitnesses, reports claim. The sky overhead, meanwhile, was a mackerel lavender.

Media experts believe that the 16 year old identity chip probably 'killed it' in the afternoon or evening, after some 'initial tip-toeing'. Experts refuse to discuss the toxicological findings at presstime, and have seized crates of Krazy Ikes and huge stacks of Fortune magazines and so forth, "as possible pieces in the bizarre puzzle", an insider said.

The time-of-death estimate is based on the quality and resolution of the image and on other definite types of situations with regards to glue and paper products about the house, insiders report. But the actual moment and mode of the Big Little Bang remains obscured by menacing slabs of uncertainty, moated in all around by a thickly fogged climate of epistimological 'Why Bother-ism', which in turn lay dormant even now, sealed freshly under a shellac-like armor coating of semiotic refusal and wholly inapropriate levity in the face of a sauntering paradigm. Many believe this smokescreen conceals much more than just mere smoke.

"We feel confident that this was a self-inflicted gunshot wound to the head," a forensics expert said after deconstructing

the remaining remains of the Beatkit Worldwide namebrand brand logo logotype. "What we're not quite so confident about are the facts of the matter surrounding this particular self-inflicted gunshot wound to the head. It's the premeditated aspect in particular which bothers me, anyway. Beatkit tipped us off 16 years ago, when it started itself up with all this 'Until 2000' business... I guess we just couldn't see it coming... couldn't see, hear, feel, or heal the forest for the trees, all along. 16 years. Oh well."

Adding indifferently, "Hey, you want to go for coffee?"

The toxicological tests determined that the level of Beatkit Gum in Beatkit's bloodstream was 1.52 milligrams per cubic centimeter, the source said. There is also evidence of Secret Beverages such as a Mile High Decaf Mocha 'El Grande' Duo-Caff with Almond Anisette and whipped cream, as well as some other black-market gums and candies not commercially available in this country. Plus upwards to two or three Nicorette skin patch dermals at a time.

The level of toxins from the gum was "a high concentration... no pun intended," said Dr. Victor Ballard, who heads the Earth Next To Last Institute in La Jolla, California.

But he added that the strength of the dose would depend on many factors, including even those as subtle as levels of Gamma radiation from that particular day's solar flare and sunspot activity were present. Go figure.

"The simultaneity of all processes and systems makes for a difficult to pin down either/or, cause/effect type of flowchart, try as we may to draw one. A *USA Today*-style pie-graph is out of the question. We'll have to just play it by ear, and keep 'doin' it for Van

Gogh', I reckon...", the new age professor quipped at a booksigning.

"One could wonder and even ask about impairment of judgement," Ballard said, "and yet, it is so like Beatkit to stick to its guns... or at least the rest of the world's target, anyway... if I may be allowed to coin a phrase."

Beatkit had taken cocaine, heroin, MDMA (ecstasy), LSD, pot, uranium, DMT, fetal shark's blood, pine tar, grass, weed, refined white sugar, mescaline, crystal meth, Secret Pepsi, Orbitz, Peeps, chocobars, and Cadmium Red before, insiders say, but never all at once like this. And never with a gun in the house. It was Beatkit's continued one-on-one war with a terminal monoculture that led Love and many of Beatkit's co-workers to attempt to persuade Beatkit to try to "get out more", maybe even "join a gym" or something. While there was still time, apparently.

One longtime friend of Beatkit's (who chose not to be identified) told *Copy Planet* reporters that the self-negating antistrategy was driven to suicide by mysterious internal forces which oversee such developments everyday. Perhaps "a Freemason thing".

"Just blaming it on drugs and pot and alcohol and on candy and steroid-usage and on sugar-coated breakfast cereals and lots and lots of psychedelic mushrooms and a Phil Dick Complex is stupid. It's a reduction", said the source.

"Everyone has been taking drugs since the beginning of time. Plants are drugs, water's a drug. Everything's a drug! Look at food! I mean, 'The National Food & Drug Administration? Am I right? Like, hello? What are we talkin' about?

"And besides, I thought we were talking about gum! Gum—even some

kind of far-out Stanley Kubrick-style psychedelic Chinese gum full of viruses—was just a small part of Beatkit, what Beatkit was about."

The source said that classic Beatkit merchandise and Beatkit Bonds are skyrocketing in value, and that there seems to be virtually no limit to what an inflated market, mainlining pop fear and celebrity heat death, will continue to bear.

The source added that he had not himself seen the film 'Uncle Buck' yet.

"I don't have it all figured out, not by a long shot. I'm no Kreskin. I'm not Nostradamus, Jr. over here, okay? These aren't even my real clothes. What use is a 5-color digital image-map of the entire human genome to all the people who died of plague in the 1200's? What about Wilhelm Reich, I suppose that was just another 'syringe hoax' to you people. Are you concerned about that mysterious quarry of stashed monkey fossils unearthed in the mid-'90s? Who cares about that now? You? Your readers? I surely don't. I'm just one man, after all."

Experts are keeping a close eye on the dormant Beatkit, and almost half-expect it to possibly rise from the dead, perhaps even in the next few hours, insiders say.

"The Resurrected Vegetation God has certainly taken on demonstrably industrial and corporate forms for us", Professor Ballard pointed out to *Copy Planet* reporters, "...not to mention ironically post-human ones! This is what we're talking about."

The jingoistic media guru seemed upbeat and brimming with "a informed meta-confidence"addin laconically, "I suspect Beatkit will b up and running again in a day or so, some form or another, perhaps even that order. Until then, everyone sta right where they are."

Fresh New!

From atop the brittle serifs of Failed History,
breeding uncanny nostalgia for The Right Now,
Beatkit™ rushed in promising obsolescence,
blessing us with a terminal view of the disrepute
into which all forms must continually fall.

PARIS • MUNICH

START

STOP

Since 1984
Beatkit
Until 2000

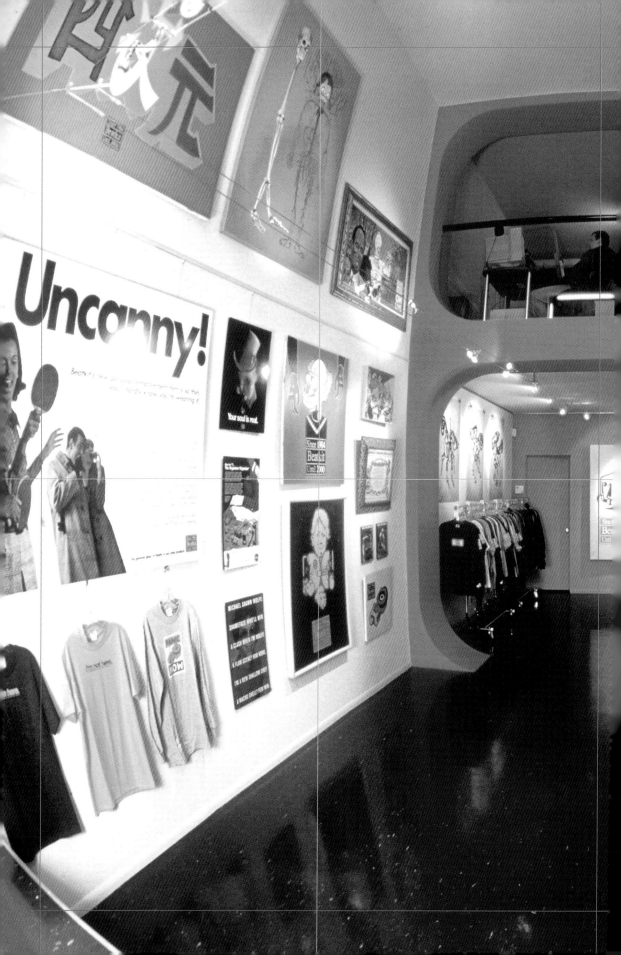

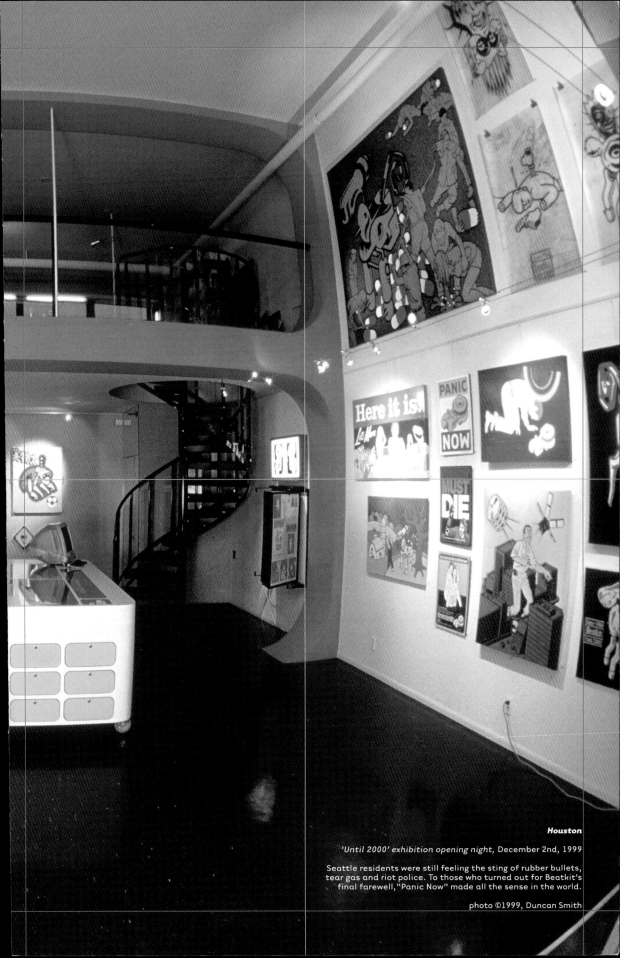

Houston

'Until 2000' exhibition opening night, December 2nd, 1999

Seattle residents were still feeling the sting of rubber bullets,
tear gas and riot police. To those who turned out for Beatkit's
final farewell, "Panic Now" made all the sense in the world.

photo ©1999, Duncan Smith